WHITLEY BAY & SEATON SLUICE

THROUGH TIME

Ken Hutchinson

AMBERLEY PUBLISHING

Acknowledgements

Special thanks go to Diane Leggett for her help and encouragement, and other staff at the Local Studies section of North Tyneside Libraries, including Joyce Marti and Ian Brown, for their help and for allowing me to use many of the photographs from their collection, which they have built up since 1974. Many of the photographs used have been donated by members of the public, and library staff are always on the lookout for additional pictures to add to their collection to be made available to a wider audience through books like this. There are too many sources to mention individually, but those worthy of a special mention are the following books: Alexander, John, *Whitley Bay, Britain in Old Photographs* (2000); Alexander, John, *Whitley Bay Past & Present* (2007); Allan, Tom, *Seaton Sluice & Old Hartley, A History in Old Photographs* (1992); Armstrong, Keith, and Peter Dixon, *From Segedunum to the Spanish City* (2010); Armstrong, Keith, and Peter Dixon, *The Spanish City* (2010); Clark, Andrew, and George Nairn, *Glimpses of Tynemouth, Cullercoats & Whitley Bay* (2008); Hollerton, Eric, *Whitley Bay, Images of England* (1999); Middlemiss, Joan, *Echoes of the Past, Holywell, Seaton Sluice, Seaton Delaval, Whitley Bay* (1992); Mood, Bill, *Having A Wonderful Time at Whitley Bay* (2010); Sharp, Mick, *The Dome of Memories* (2011); Thornton, A. W., *Whitley Bay in Old Picture Postcards* (2001).

In addition, all the local newspaper articles based on local postcards, published over the years by local studies staff, are a great source of information as well as inspiration for those interested in local and family history. Eric Hollerton, Alan Hildrew and Diane Leggett have been responsible for providing the majority of this information every week for many years. Another very good source for information is the website of both the Seaton Sluice and Old Hartley Local History Society (who meet every second Tuesday of the month in Seaton Sluice), and Friends of Holywell Dene (who meet on a regular basis). Both groups are full of enthusiasts about the local area and are keen to welcome new members and visitors as well as wanting to hear from anyone who has memories or pictures of the area. Thanks go to Rosie Rogers and Amberley Publishing for asking me to write the book and for their help in producing it. Thanks to my wife Pauline for proofreading the text. Again many thanks go to my family and friends for their continued encouragement and support.

Ken Hutchinson

First published 2013

Amberley Publishing
The Hill, Stroud
Gloucestershire, GL5 4EP

www.amberley-books.com

Copyright © Ken Hutchinson, 2013

The right of Ken Hutchinson to be identified as the Author of this work has been asserted in accordance with the Copyrights, Designs and Patents Act 1988.

ISBN 978 1 4456 0541 8

British Library Cataloguing in Publication Data. A catalogue record for this book is available from the British Library.

Typeset in 9.5pt on 12pt Celeste.
Typesetting by Amberley Publishing.
Printed in the UK.

Introduction

Whitley Bay and Seaton Sluice started life as small villages and have both developed into large settlements, separated by a stretch of spectacular North East coastline and dominated by the iconic landmark of St Mary's Lighthouse. They are linked by a seafront trail, leading to the lighthouse, which is well used by walkers and cyclists every day. Over the years both settlements have seen many changes, with Seaton Sluice losing its coal and bottle-making industries and Whitley Bay developing rapidly as a seaside resort following the railway arriving from Newcastle. Landmark buildings were lost in Seaton Sluice and others developed at Whitley Bay, leading to a transformation of each settlement over time.

The name of Whitley is thought to come from early Angle settlers who referred to it as 'White Lea' or pasture land. The first records of the name go back as far as 1116, and Ralph de Whitley was the owner in 1225. It was owned by the Prior of Tynemouth until 1539, and from 1750 by the Duke of Northumberland. A lot of street names are linked to the family, e.g. Percy Road, Duke Street and Alnwick Avenue. Whitley started life as a small agricultural village, centred around what is now the present town centre, between St Paul's church and Victoria Terrace. The short main street was called Front Street, with the large house and grounds of Whitley Hall on the south side, and the large Whitley House and the Victoria Hotel on the north side, together with a number of inns, modest cottages, a forge and other businesses making up the village.

From the 1670s coal mining developed in areas around the village as well as a limestone quarry dating from 1684 at Marden and another at Whitley Quarry at Hill Heads. Whitley Colliery operated 1817–48 to the south of the village, close to the present Metro station, and had its offices in the village. St Paul's church was built to the west of the village in 1864 to serve the Cullercoats parish when the Tynemouth parish was divided in two.

When the railways reached Whitley Bay in the late 1800s, the town developed rapidly as a holiday destination both for Tyneside and beyond. It also became a popular residential commuter town for Newcastle. A large number of impressive terraced houses were built by the wealthy, both close to the railway station and with views over the sea, as well as hotels, guest houses, shops and visitor attractions.

The town was called Whitley Bay from 1901. This followed an unfortunate event when a former resident of Tynemouth, William Oliver, died in Scotland and was sent back to Whitley by train to be buried at St Paul's. There was a mix-up with the names of the destination and he ended up in Whitby instead. His relatives and friends waited in vain at Whitley station. It took until nearly 9 p.m. that night for the body to be sent on to Whitley for a belated candlelit burial. This tragic mix-up, on top of a number of other similar instances involving mail deliveries, led to strong representations being made to the authorities. It was agreed, after consulting local residents, to change the name of the town to Whitley Bay to avoid a repeat in the future.

The famous iconic Spanish City Dome was built in 1910 and formed part of the Whitley Bay Pleasure Gardens that became a magnet for holidaymakers as well as locals from Tyneside. This continued during the first half of the twentieth century, and Whitley Bay became one of the North East's premier holiday resorts until the 1970s, when holidays abroad became popular, guaranteeing sunshine and warmth to go with the sandy beaches. Whitley Bay was particularly popular with people from Glasgow until the 1960s; large numbers of Glaswegians would descend on the town during the 'Glasgow Fortnight'.

The name of Seaton was derived from a settlement (ton) beside the sea. It was situated about half a mile north of Hartley village and formed part of the old Manor or administrative area.

Hartley is first recorded in 1097, and the local landowning family who had come across with William the Conqueror, the de la Vals, adopted the name Seaton for the nearby settlement of Seaton Delaval. Seaton became Seaton Sluice in the 1660s when Sir Ralph Deleval erected sluice gates at Seaton, to block the Seaton Burn and to hold water back. The water was then released to sluice the sediment in the harbour to improve navigation for ships exporting coal and salt from the harbour.

The harbour was further developed in the 1760s when Sir John Delaval made the impressive 'Cut' through solid rock at Seaton Sluice to provide a twenty-four-hour loading facility in the harbour to export coal, salt and bottles from a major new bottle works he built on the site with his brother Thomas.

Industry dominated the town for the next century and the Royal Hartley Bottle Works was formed by the Delaval family. It produced over one million bottles a year, and almost all the occupants worked for the Delaval family. They also lived in houses built by the Delavals, shopped in their shops, and drank in their pubs – the beer had been brewed in the town's own brewery. A doctor was also available for the workers.

The bottle works closed in 1872 and exports of coal stopped following the Hartley Pit Disaster in 1862. Trade in the harbour declined and Blyth developed to be the principal port. The six landmark cone furnaces were demolished in 1897. The town continued to provide labour for the local collieries.

Seaton Sluice has now extended to the adjoining village of Hartley, later to be called Old Hartley, to distinguish it from the village of New Hartley, built around a new colliery developed in 1850 about 3 miles inland to the north west. Hartley village was an agricultural village between Whitley and Seaton villages. Holywell Dene, an attractive, steep-sided, wooded valley and important wildlife habitat, extends inland from Seaton Sluice, forming the southern boundary of Seaton Delaval Hall estates.

I was asked to write this book following the success of writing similar books on *Wallsend Through Time* (2009) and *Tynemouth & Cullercoats Through Time* (2011). Again I have worked closely with staff in the Local Studies Library at North Tyneside and made use of their extensive postcard collection. I worked for North Tyneside Council for over twenty-nine years as a Town Planner and knew Whitley Bay very well. The first family holiday I can remember in the late 1950s was in Whitley Bay. We travelled all the way from Wallsend and hired a holiday house for a week. It was a short walk from the sands and the Spanish City. I have also lived in Monkseaton, part of Whitley Bay, for over twenty-three years. In retirement I have been a volunteer at Seaton Delaval Hall and have got to know Seaton Sluice well, as it was developed by the Deleval family who lived at the hall.

As the book is published in colour, I have used as many colour postcards as I could find from the Local Studies collection in North Tyneside Council Libraries. Although Seaton Sluice does not now fall within North Tyneside, it was previously part of the Whitley Bay Urban District Council before the 1974 reorganisation. The library still has a very good collection of postcards from Old Hartley, Seaton Sluice and Holywell Dene. This book concentrates on the changes that have happened over the years, to hopefully bring back memories of buildings that have disappeared, as well as showing some of the buildings that used to exist on sites that nobody can remember. The pictures are arranged to follow a scenic walking route along the coastline between Whitley Bay and Seaton Sluice, starting at Whitley Bay Metro station and ending at Seaton Delaval Hall – fittingly the two main influences on the growth and development of both towns.

As with any book of this type, there will inevitably be some errors, for which I apologise in advance as I have not been able to check every name, date or detail at the original source.

The book is dedicated to my wife Pauline and my sons Peter & David. All royalties from the sale of this book will go to the Local Studies Section of North Tyneside Libraries to further develop the valuable collection of postcards, books and other records that provide an invaluable source of information for those interested in local and family history. This is the fifth book I have written in partnership with the Local Studies Section who have not only allowed me to use their postcards but have always been a great source of information, help and encouragement. Any donations received after the publication of the book will be given to St Oswald's Hospice.

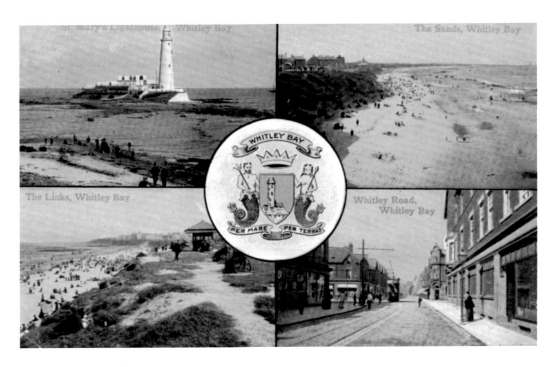

Whitley Bay Views

Two postcards dating from before 1909 (above) and before 1920 (below). Both feature the sandy beach, and the earlier highlights St Mary's Lighthouse. Whitley Bay's town crest is also featured; it is made up of a shield, with a lighthouse inside and a crown above, flanked by a merman and mermaid. The motto below *Per Mare Per Terras* means 'By Sea, By Land'. The later card features two buildings built in 1910: the new railway station and the Spanish City Dome.

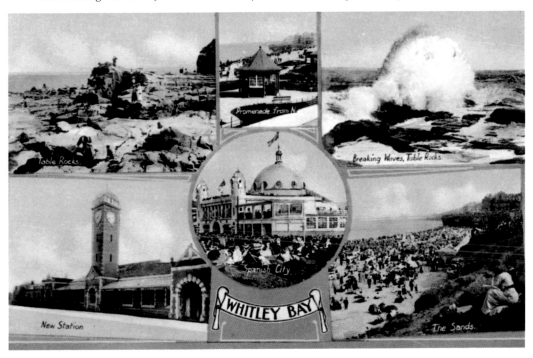

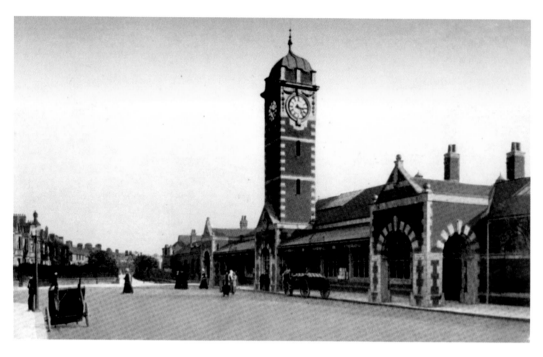

Whitley Bay Station

The new station was opened in 1910 to replace the earlier modest station of 1882, which was built to serve the new Tyneside railway loop linking Newcastle with the coastal towns of Tynemouth, Cullercoats and Whitley Bay. The grand design, dominated by the landmark clock tower, reflected the growing importance of the holiday resort. It was designed by William Bell. Outside the station is the rare K4 red telephone box, with an integral postbox and stamp sales machine, which is now a listed building.

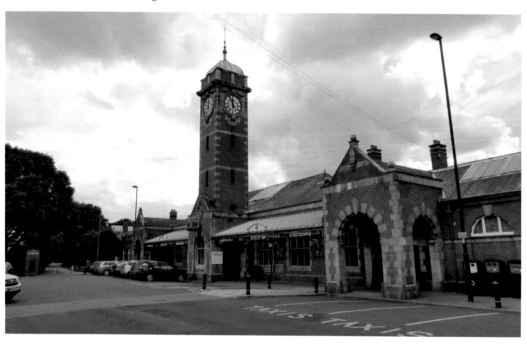

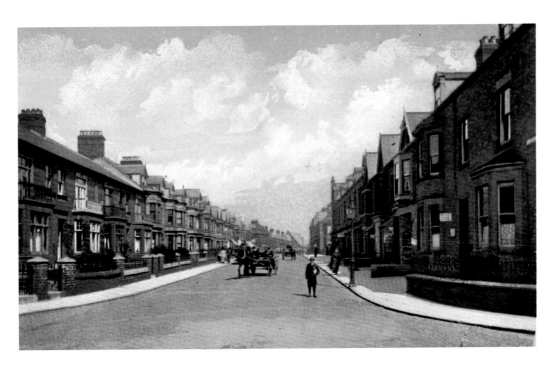

Station Road, Looking North from Station, *c.* 1925

Station Road was built to link the new station to the existing village of Whitley via a new road called Whitley Road, which extended east from Front Street in the village. The buildings nearest the station were originally built as houses, but many were later converted into shops and other commercial premises. By 1897, there was no direct link from Station Road to the sea, as Esplanade had not been completed and the Promenade was under construction. Housing had been built to the east, and Percy Road extended to the seafront.

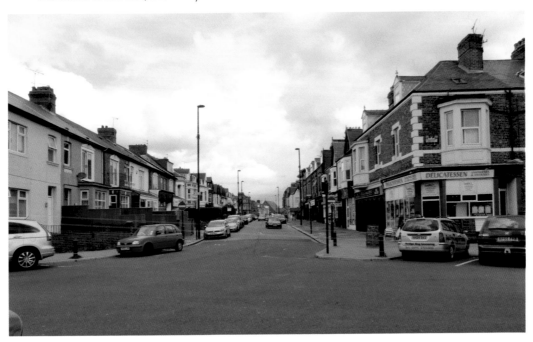

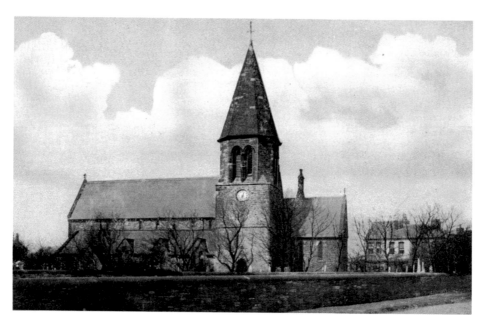

Whitley Church

St Paul's church was built in 1864 to serve the parish of Cullercoats, including the village of Whitley and the surrounding settlements of Whitleyhill Heads and Monkseaton. It was designed by Anthony Salvin for the Duke of Northumberland and was built at the western end of the village on the junction of the roads to Monkseaton, Cullercoats and Marden. It also had a large vicarage and a school built along what is now Park View shopping street. The church itself has changed little apart from having a new hall added in 2000.

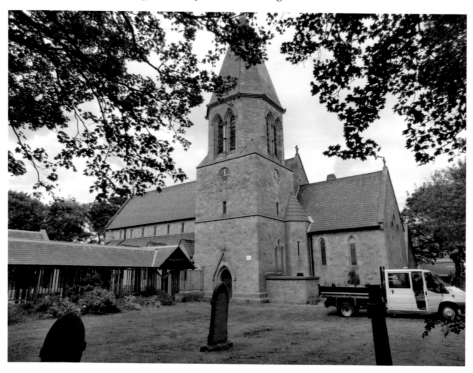

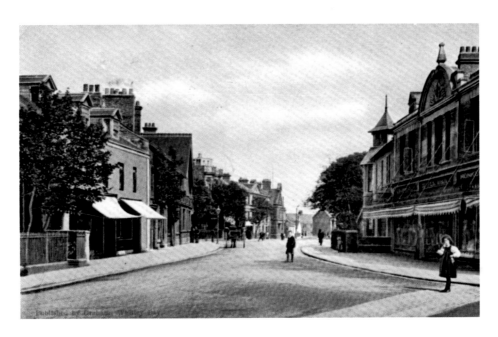

Whitley Village Centre from Church

The old view dates from before 1905 and shows the branch store of North Shields Industrial Society, built in 1902 on the right. On the left is the Ship Inn, with the cart outside, which was rebuilt around 1895. The trees are in the garden of a house adjoining the Fat Ox Hotel that had been rebuilt in 1869, before the present 1930s building. Further west was Mr Steel's Market Garden. George Steel occupied the site from 1901 until 1926, when it was widened and developed as a shopping street with housing beyond.

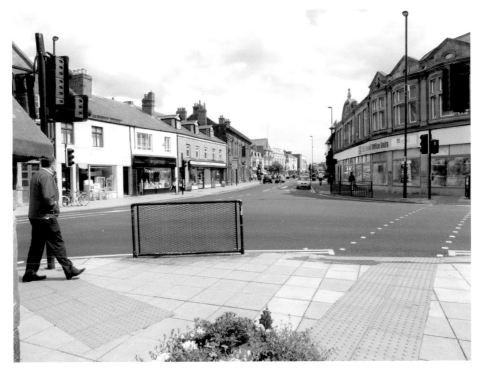

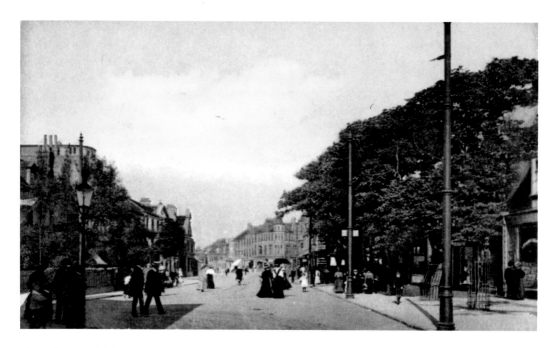

The Village, Whitley Bay

The postcard from around 1909 shows mature trees on the right, which were cut down in 1922 and originally stood within a stone boundary wall outside Whitley Hall, built in 1760 and demolished in 1900. Shops and houses have been built behind the trees. On the north side of Front Street you can see trees in the gardens of Ivy House, on the corner of Park Avenue, along with Belvedere House, built around 1800, and Whitley House, built around 1830. The white-faced Belvedere buildings were built around 1926. In the distance Central Buildings dominate the corner of Whitley Road and South Parade.

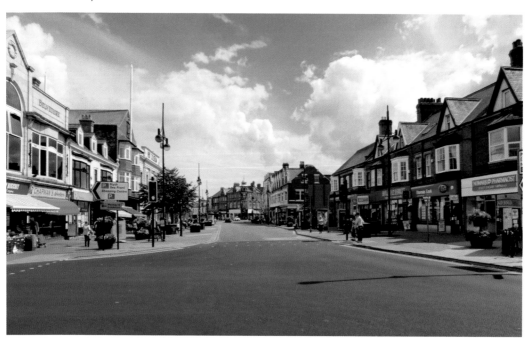

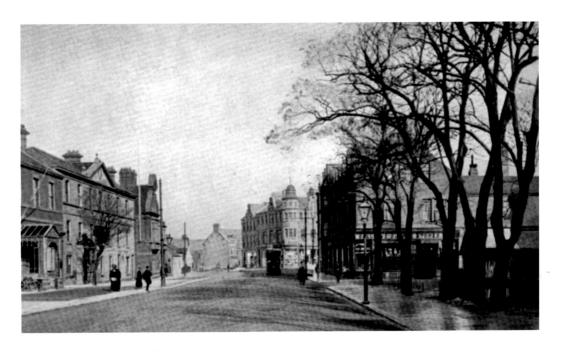

Regent Street, Whitley Bay

The postcard is dated 1904 and refers to the street as Regent Street. The street was known as Front Street on the 1897 Ordnance Survey Map and was later renamed as part of Whitley Road. On the left you can see Whitley House, replaced by the Coliseum Theatre in 1910 and then the ABC cinema in 1923. Later it was Victoria Hotel, now the Bedroom, and the Council Offices that are now B&M. Beyond, the gable of Lindon Terrace is visible. In recent years, houses have been built along South Parade from Central Buildings. The HSBC Bank occupies part of the site of Whitley Hall.

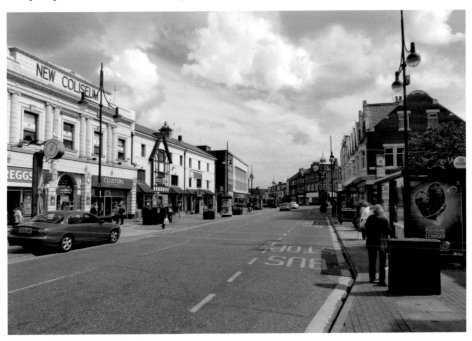

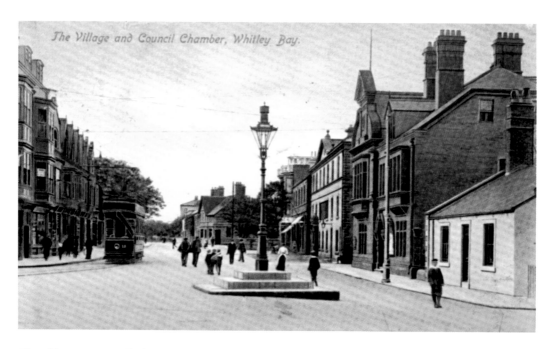

The Village and Council Chamber, Whitley Bay.

The Village & Council Chamber

The Council Chamber seen here before 1905 was built on the site of a former cottage and opened on 1 June 1901 for the Whitley & Monkseaton Urban District Council. From 1922, some of the ground floor was let as shops, and Woolworths built a shop next door in 1927. In 1955 Woolworths redeveloped both sites to form a large store. Charlton's Smithy (blacksmith's) stood in the middle of the road and was demolished in 1901. The big lamp, built on the site, was a popular meeting point for a few years before it was removed.

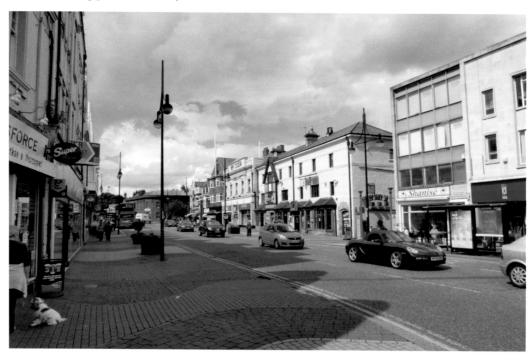

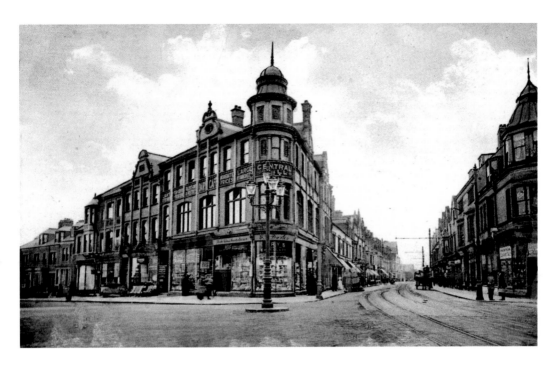

Whitley Road from Village

The Central Buildings were built around 1900, the same time as the Imperial Buildings on the opposite corner. The grand Edwardian architecture reflects the growing confidence in the development of the town as a commercial centre to serve the rapidly expanding community. The postcard dates from around 1910. Streets that did not have any buildings on them in 1897, such as South Parade, were complete by 1910, offering a range of shops, banks, boarding houses and hotels. Povesi's Assembly Rooms were just along Whitley Road on the north side.

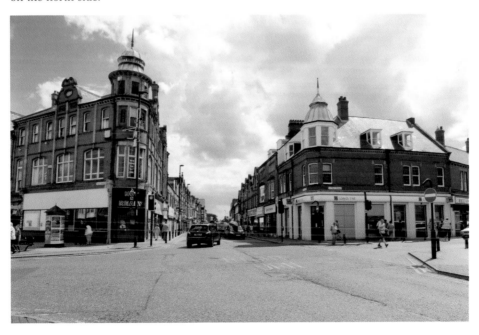

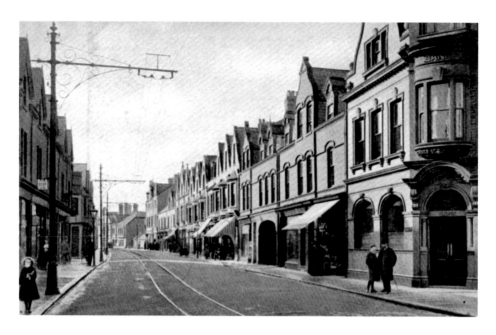

Whitley Road from Station Road

The postcard dates from before 1905 and shows some of the first purpose-built shops and commercial premises in the newly expanding town centre of Whitley Bay. It led directly from the original Whitley village core, which was seeing its old buildings being pulled down and redeveloped. On the right, on the corner of Esplanade, is the impressive edifice of the future Barclay's Bank. This was one of the first buildings built along this side of Whitley Road before 1897. The trams operated from 1901 to Front Street then to the Links in 1904.

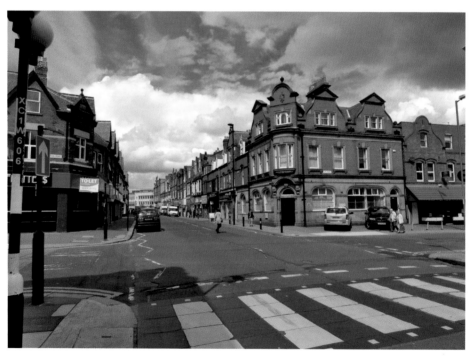

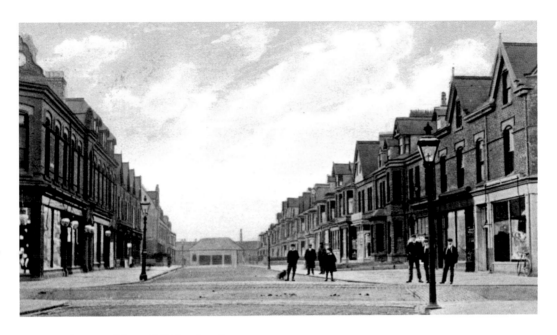

Station Road from Whitley Road

Captured before 1905, the view on the postcard shows the original 1882 station in the distance, which was a simple low level building with no great ornamentation. It was built at a time when Whitley was a small village, and the coastline cliffs and sands were untouched by visitors, who tended to be attracted to Tynemouth. By 1908 it was felt that Whitley Bay needed to have an impressive landmark clock tower, to direct the growing number of visitors back to the station after their visit to the resort. The new station opened in 1910.

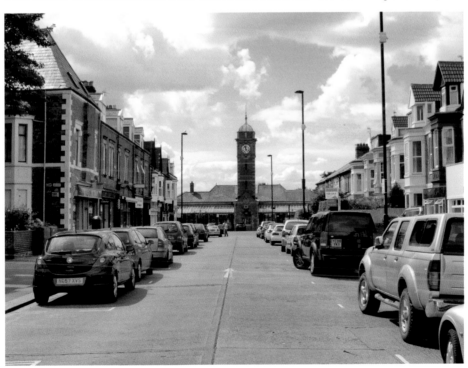

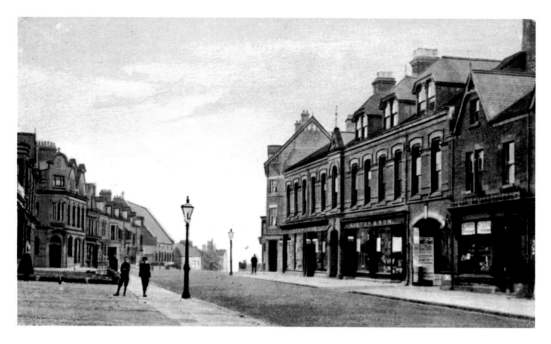

Esplanade from Station Road, 1927

This postcard shows Station Road looking north towards Esplanade. Many shops were well-established on this part of Station Road close to Whitley Road, with the Station Hotel dominating the end of the street on the right and Barclay's Bank on the other corner. Further down Esplanade can be seen the Presbyterian church, built in 1900, beyond the substantial three-storey dwellings close to Whitley Road. There still seem to be some vacant plots beyond.

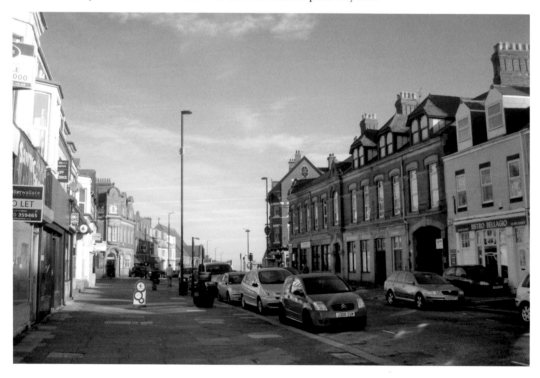

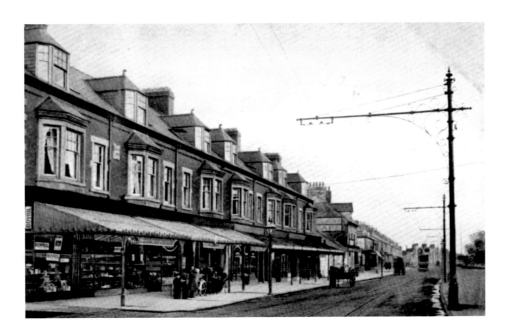

Arcadia, Whitley Road

The picture, dating from before 1905, shows the original glazed canopies in front of the purpose-built shopping arcade, which were a feature of many seaside resorts developed around this time. Places like Saltburn still have some of these canopies but all have been lost in Whitley Bay. The only remnant of the arcade is an engraved stone above the modern shops stating 'Arcadia'. The post supporting the overhead tram cables features prominently and a tram can be seen in the distance. One of the shops is a bicycle shop with bicycles outside.

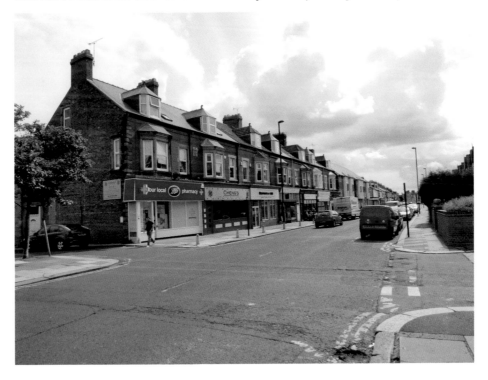

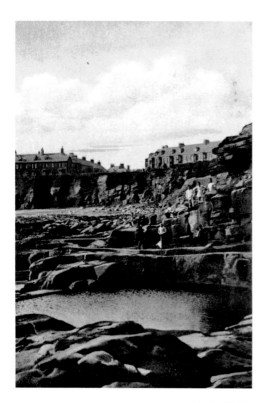

Swimming Baths, Table Rocks

As Whitley Bay and Cullercoats developed as seaside resorts, the numbers of people swimming in the sea grew steadily. Following a number of accidents involving the loss of life due to dangerous currents, a safe swimming pool was created at Table Rocks in 1894. The pool utilised a natural hollow feature in the rocks, and an artificial dam was built on one side to create a swimming pool. The pool was doubled in size in 1908. This postcard view showing Promontory Terrace was taken before 1911.

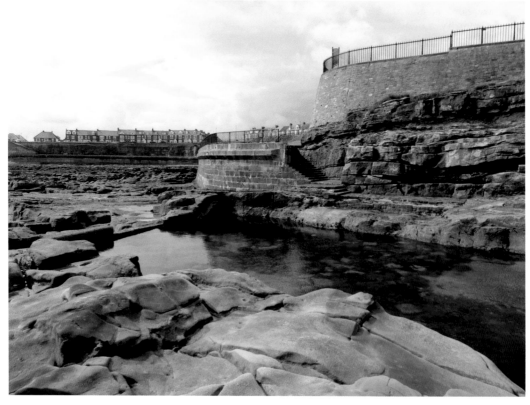

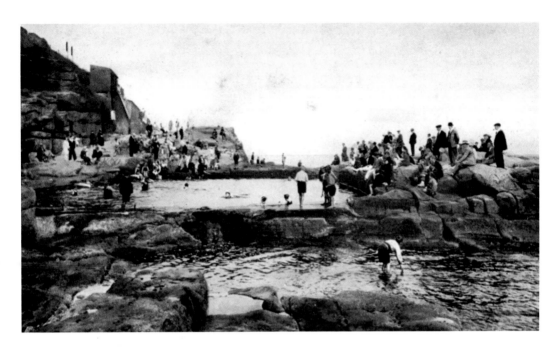

Table Rocks Swimming Pool

This view looking north was captured around 1912 after the hut was built to provide changing facilities for the Whitley & Monkseaton Bathing Club, established in 1910 and known as 'The Winkles'. The hut was lost in gales four years later. Steps were cut down to the pool, and ropes were erected around the edge. It was well used for a number of years. The building of the outdoor pool in Tynemouth in 1925 led to its decline in popularity, but it was still used till 1971. The next major pool in Whitley Bay was the indoor leisure pool, built in 1974.

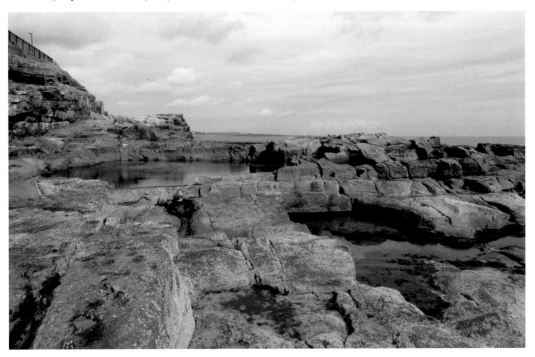

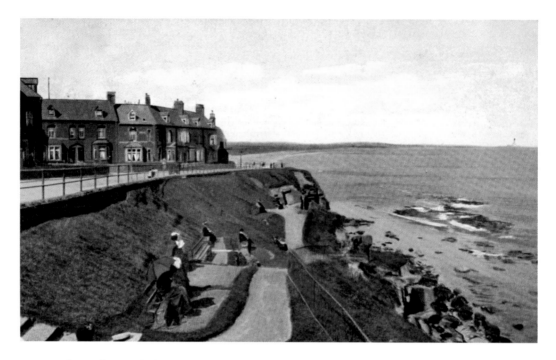

Muir Gardens, Whitley Bay

Muir Gardens was developed by the Local Board of Health in the late 1890s to provide some communal gardens leading off the recently built Promenade overlooking the sea. Whitley was starting to change rapidly and the newly built houses of Percy Road and Victoria Avenue were built towards the sea, to the south-east of the new Whitley station that opened in 1882. Seen here before 1909, they were later renamed Victoria Gardens as they were beside Victoria Avenue and Victoria Park on the other side of the Promenade.

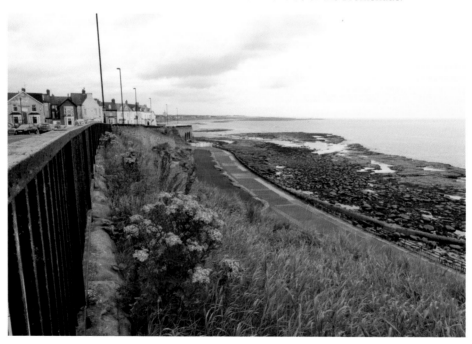

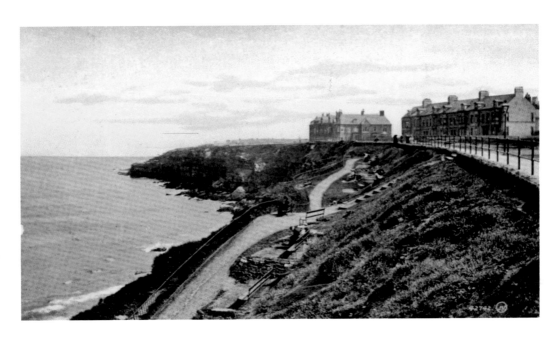

Victoria Gardens, Whitley Bay
The postcard is dated 1911, and only a few terraced properties had been built along the Promenade. The far block was built before the Young Women's Christian Association building was built beyond it in 1912; it later became the High Point Hotel. The Table Rocks pool is just out of shot around the headland, and the Southern Lower Promenade was constructed in the 1930s, including a paddling pool, the remains of which still exist. The gardens were removed to provide the dog-leg path down to the Southern Lower Promenade.

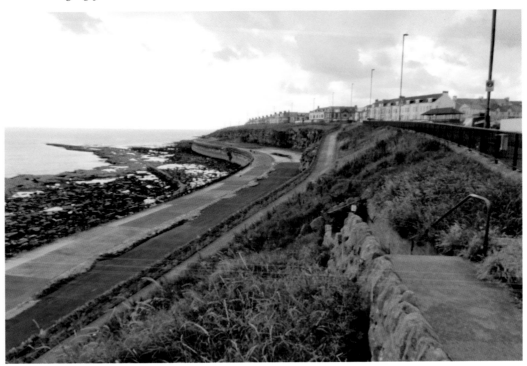

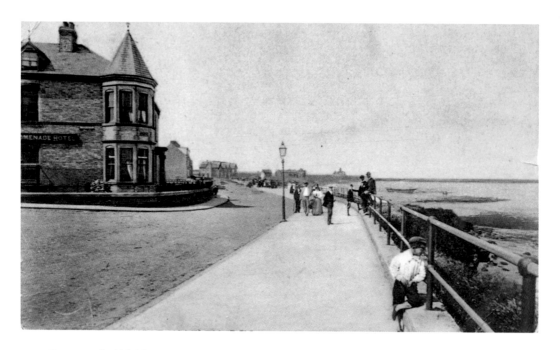

Promenade, Whitley Bay

The Promenade Hotel is seen here before 1907 on the corner of Percy Road. The house was originally built for Alfred Styan (1840–1902), a local builder, who built a lot of the nearby streets, including Percy Gardens and Victoria Gardens. Styan Street is named after him. It was originally called Redcar House and later became the Grand Temperance Hotel. In the 1980s it was known as the Queens Hotel, then it became Whiskey Bends before becoming disused. In the later picture the Promenade was undergoing restoration works in 2012.

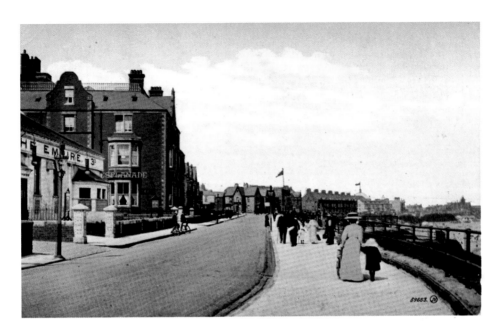

Promenade & Empire Cinema

The postcard picture was taken after 1915 and shows the first purpose-built cinema in Whitley Bay, The Empire, which opened in 1910 and stood on the corner of Esplanade. The building was later modified in 1922 to form the New Empire, and it became the Gaumont in 1950, which closed in 1960. It was later home to the Alletsa Ballroom and was known as Sylvester's from around 2000, before being demolished around 2008. The Esplanade Hotel, built in 1902, was a nightclub and hotel until it was converted into flats in 2012.

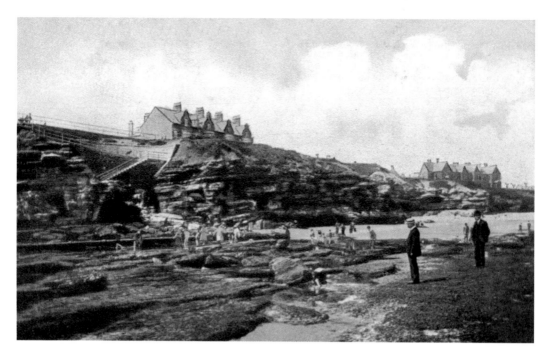

Corkscrew Stairs

In 1895 the Local Board of Health for Whitley Bay started to build the Promenade between what is now Rockcliffe and East Parade. This included providing a new means of access for pedestrians to the beach, known as the Corkscrew Stairs, as they spiralled down the cliffs and resembled a corkscrew. The postcard dates from 1905, and the cliffs at that time were very precarious and unprotected from the full force of the sea. The present sea defences and lower promenades were added in the 1920s and 1930s.

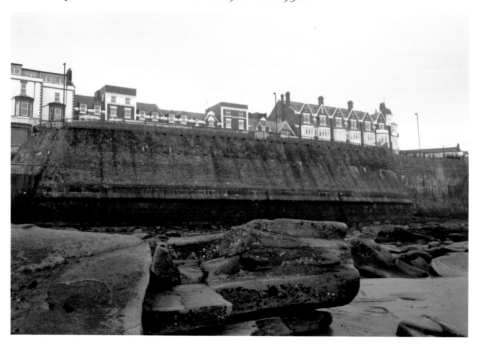

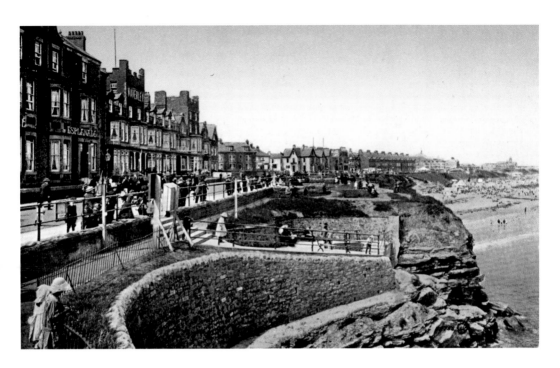

Promenade & Corkscrew Stairs

The Waverley Hotel, adjoining the Esplanade Hotel, was originally built as a temperance hotel and was opened in June 1907. It expanded over the years, taking in more property, and by the 1920s it had 150 rooms and an impressive ballroom. It became the Rex Hotel in 1937 and still dominates the seafront. The Corkscrew Stairs were sited opposite Esplanade, which led directly to the railway station. This was to be the site of Whitley Pier, proposed in 1908, but it was never built, and instead new lower promenades and sea defences were constructed in its place.

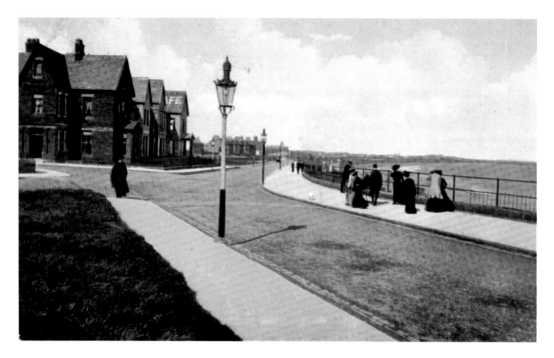

Esplanade

The newly constructed clifftop road, around 1910, was referred to as Esplanade. The grass in the foreground is on the site of the Rex Hotel, with the corner of South Parade beyond. The building on the corner now emblazoned with 42nd Street was known as Corner House in the 1920s, with a tobacconist on the ground floor and a café above called the Manor House Café. Gregg's Café, beyond, was built by Henry Gregg in 1905, who lived behind it; he later became Mayor of Tynemouth (1914–18) and was knighted for his war service.

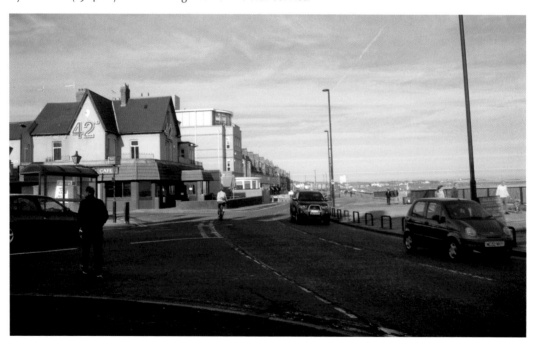

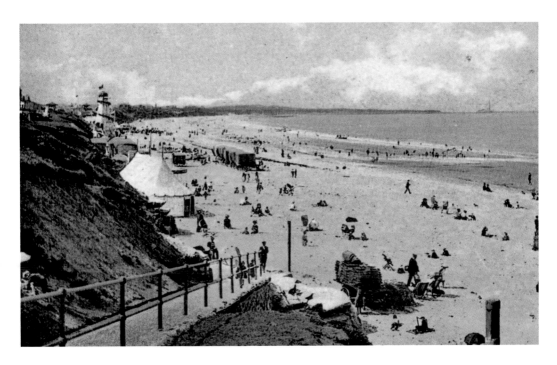

The Sands, Whitley Bay

The postcard dates from around 1910. The slope leading down to the beach from the Promenade was known as Gregg's Slope. In the distance the helter-skelter is visible, situated beside Watts Slope, beyond a row of bathing machines. John Dunn introduced bathing machines to Whitley Bay in 1870 and they were still a feature on the beach forty years later. Following the building of the Central Lower Promenade in the early 1920s he opened Dunn's Tea Rooms – a family business that lasted till the 1960s.

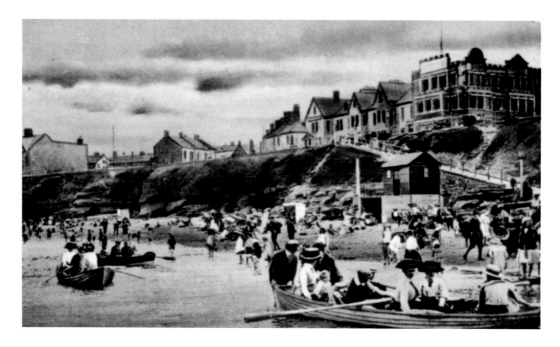

The Sands from the Beach

Gregg's Slope is seen around 1910. It was named after Gregg's Café, a prominent landmark. The building was used as a rest home for the elderly for many years and was recently extensively rebuilt to provide sheltered housing. The rowing boats were probably owned and run by the Watts family of Watts Slope. Following four boys being swept to their deaths in 1912, a patrol boat and hut for storing safety equipment at the foot of the slope were provided. Today the lifeguards provide a similar service during the summer months at the same spot.

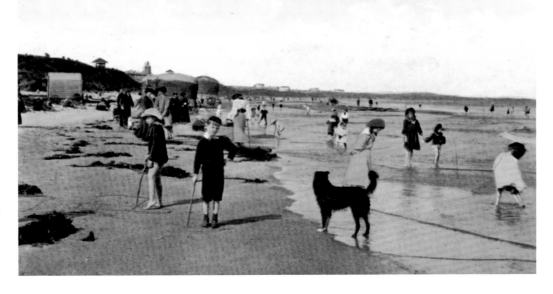

On the Sands

The postcard is dated 1907 and looks north from the sands, with the Prudhoe convalescent home in the distance, just beyond the bathing machine. The children greatly outnumber the dogs on the beach, whereas today the dogs quite often outnumber the children. Swimming has remained a popular pastime and the headquarters of the Panama Swimming Club, built in the 1950s, is seen in the distance in the later picture. Members of the club swim every week, all year round, and hold a major event every New Year's Day when anybody is free to join in.

The Beach, Donkey Stand

The postcard dates from 1929 and shows the donkey stand on the beach, with Watts Slope beyond, leading from the Spanish City Dome, and Watts Café on the north side of the slope. Donkey rides were popular on the beach for many years and were run by Mr Hunter from before 1905 to the 1960s. Donkey Derby's were held between the wars. Watts Slope and Café were originally developed in 1865 by Andrew Hodgson Watts, and Watts Café was run by the family for generations. The building still operates as a restaurant/café.

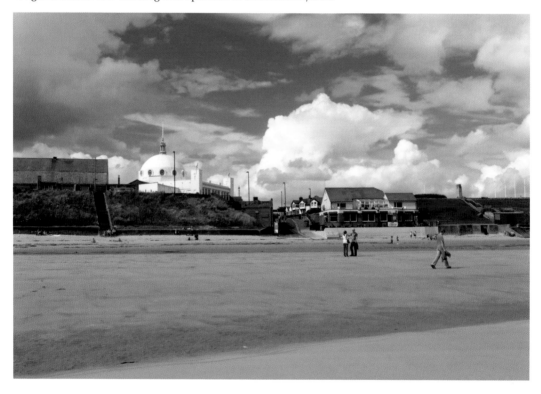

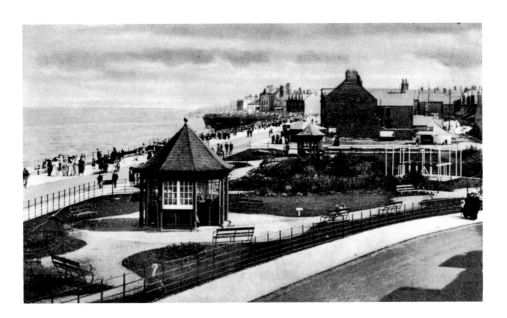

Promenade Looking South

The view of Promenade Gardens, later known as Brook Street Gardens, was captured before 1926 at a time when Whitley Bay was a very popular seaside resort, with many well-cared-for gardens, seats and shelters overlooking the sea provided for visitors. Crowds of people in their best clothes can be seen walking along the Promenade from the Waverley Hotel and past the Royal Hotel. The hotel opened in 1911 on East Parade, and its gable wall fronts onto the gardens. The new diverted coastal road now bisects the gardens passing behind the Dome.

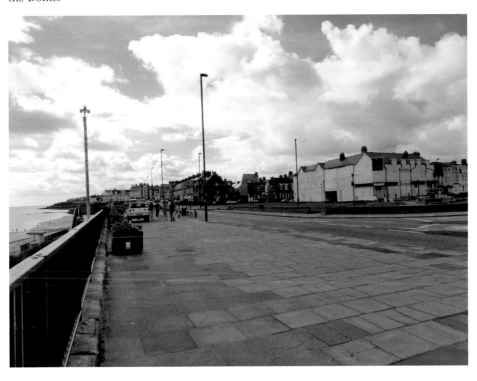

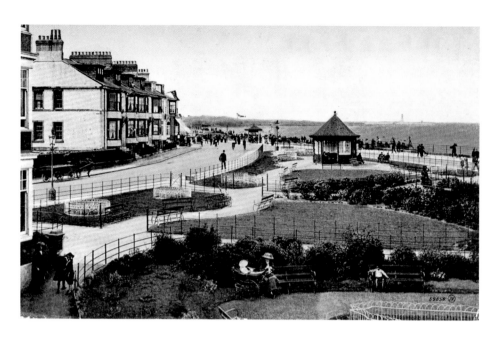

Promenade Gardens

Looking north across Promenade Gardens around 1917, the corner of the Avenue Hotel can just be seen on the left of the picture above the lady and two children. The terrace beyond is Whitley Park Terrace, built in the 1860s as five-bedroom houses with coach houses and stabling. They still seem to be in residential use at this time, before being converted to commercial uses including the Willow Café, the Carlton Café and the Pickwick nightclub. All are demolished. The only vehicle on the road is a horse and cart.

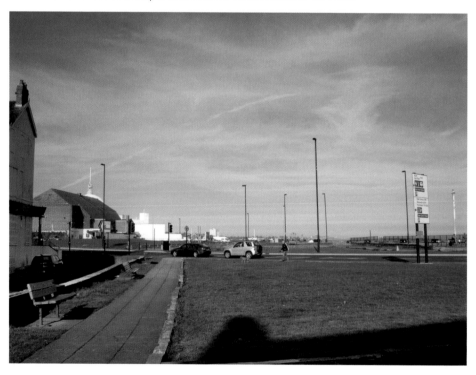

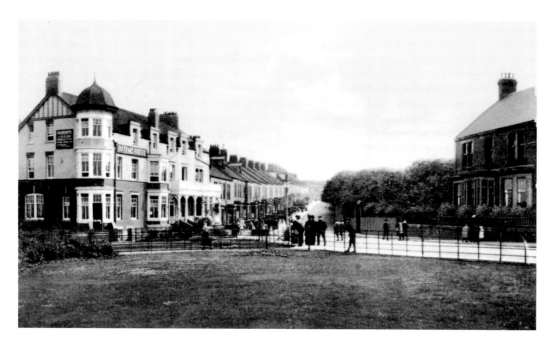

Park Avenue

Park Avenue is shown on the Ordnance Survey Map of 1897 as a tree-lined avenue to the south of the extensive grounds of Whitley Park, a large house built originally in the 1700s. The Avenue Hotel & Restaurant was built on the south-east corner in 1907 by Thomas Patterson. It was run originally by Mrs Mary Morgan, with the Whitehall next door fronting on to Brook Street. The Avenue was used as a public house until the 1990s. The building on the right is Priory House, which was built in 1893 as a convalescent home by Mrs Ann Philipson.

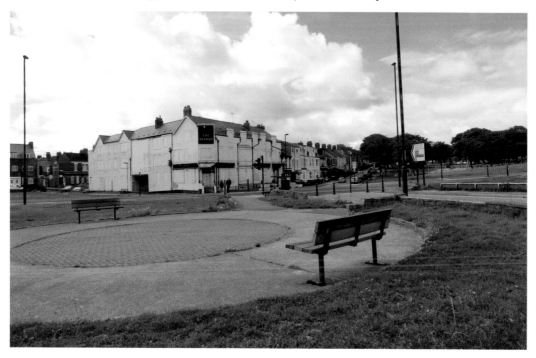

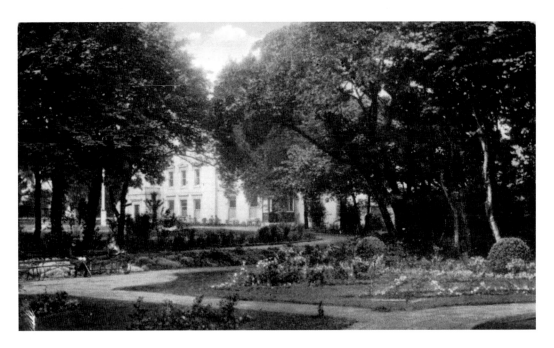

Council Chambers, Whitley Park

The former Whitley Park Hall was converted to the Park Hotel after 1879 and was used by the Army during the First World War. The local Council bought the property in 1922 and briefly used it as offices before moving into the former Priory Catering Co. Buildings, which had been converted from wartime buildings that were erected in the south-east corner of the park. The former hall was demolished in 1939, and the council buildings were demolished in the 1990s. The council converted part of the grounds into a park and built a new library on the site in 1966.

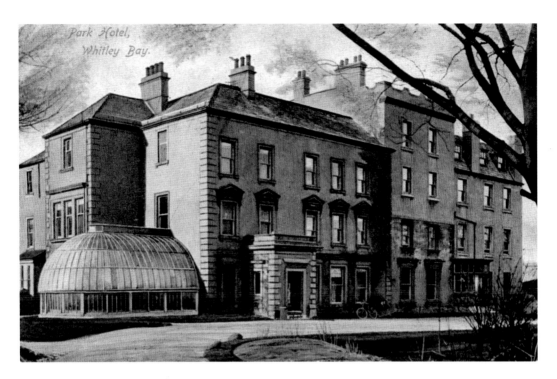

Park Hotel, Whitley Bay

Mr Edward Hall built Whitley Park Hall in 1789, in extensive grounds on the site of an earlier hall. The hall was later extended by T. W. Bulman, who had bought it in 1857. He diverted the road around his property and planted the tree belt to the south that still exists today. After he died in 1879 it was taken over by the Whitley Park Hotel Company, which later developed the grounds into the Spanish City Pleasure Grounds. After the First World War the council tried to use the hall as offices but found the accommodation unsuitable.

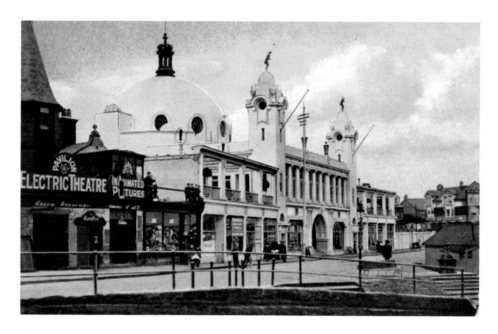

Pleasure Gardens & Electric Theatre

Mr Robert L. Grice built the Sea Water Baths Pavilion in 1897 and later started to show pictures in the pavilion from 1910, when it was renamed the Electric Theatre Pavilion; the postcard dates from around this time. It continued until 1923 when it was burnt down in a fire. The Spanish City also started to show pictures in 1916 and this continued until 1963. The hut to the right of the picture is 'Smith's Tea Room' at the top of Watts Slope, first established in 1890 by Robert Smith as cocoa rooms.

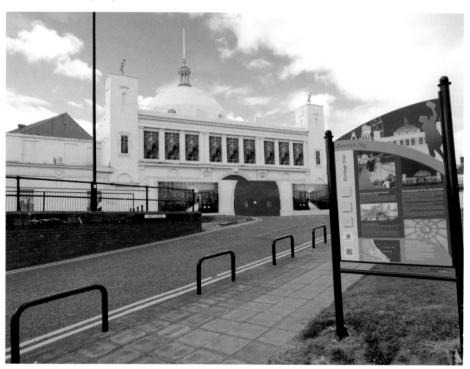

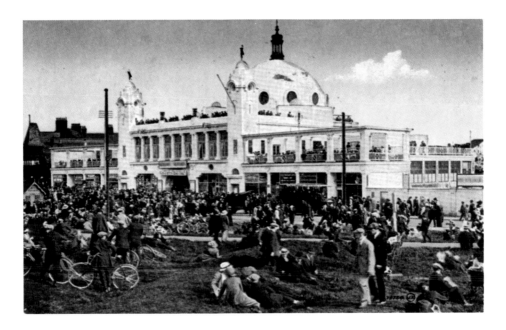

Pleasure Gardens, c. 1919

The Pleasure Gardens, or the Spanish City, are known mainly by the iconic Dome, the centrepiece of the purpose-built visitor attraction that included the impressive Empress Theatre. Designed by Newcastle architects Cackett & Burns Dick and built in 1910 using the latest technology and building materials, it was one of the first structures built using the new Hennebique reinforced-concrete system. It was the second-largest Dome in the country after St Paul's Cathedral in London.

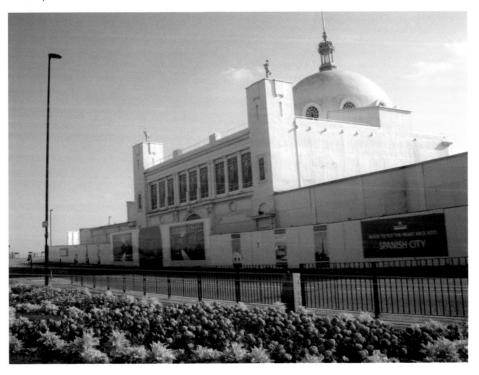

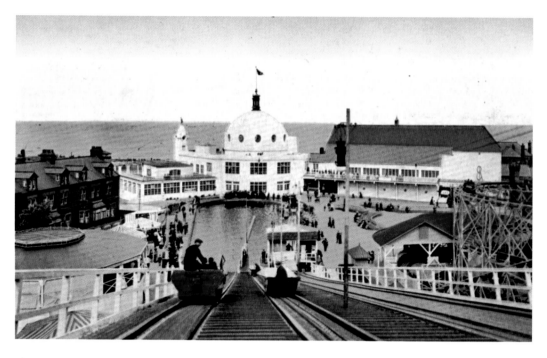

Pleasure Gardens from Water Chute

The Spanish City got its name well before the Dome was built. The site was developed as an entertainment complex, linked to and in the extensive grounds of the Park Hotel. The Spanish theme came from a troupe of Toreadors who used to entertain visitors on the site. The company organising summer concerts, Whitley Amusements, built a number of Spanish-style buildings around them as a backcloth to their performances. The Water Chute is seen here around 1910, and the western part of the site is now occupied by a school.

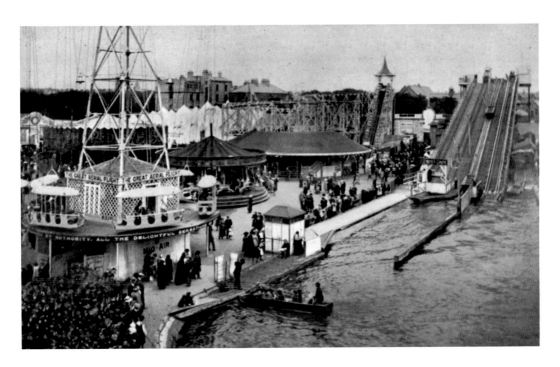

In the Pleasure Gardens

The Spanish City is immortalised by Mark Knopfler in the song 'Tunnel of Love', and over the years the rides constantly changed to maintain their attraction to visitors. The Water Chute was replaced by the Virginia Reel in 1932, and even as late as the 1980s the need for a major attraction led to the building of the Corkscrew rollercoaster that was in place for less than ten years. The days of the Spanish City as a fairground were numbered; eventually the site was abandoned for redevelopment, but a travelling fair still visits the Links each year.

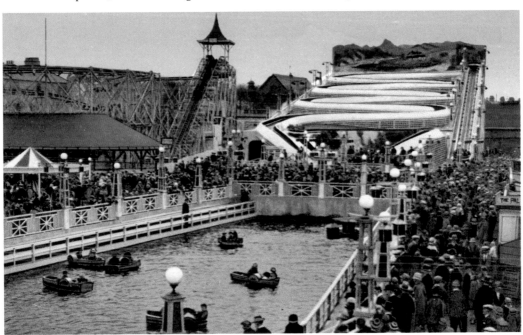

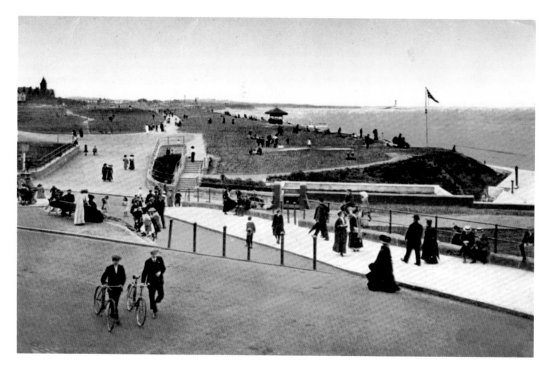

The Links & Watts Slope

This view to the Links, over Watts Slope, dates from around 1913. On the left of the picture is a drinking fountain that stood beside Smith's Tea Rooms, just off picture. To the right are the recently constructed public conveniences on Watts Slope, with Watts Café at the bottom of the slope. In the distance can be seen the Prudhoe Convalescent Home and its windmill standing close to where the Rendezvous Café now stands. A pleasure steamer operated by Fry's can be seen in the distance. The green lamp, on the right, is a sewer gas lamp.

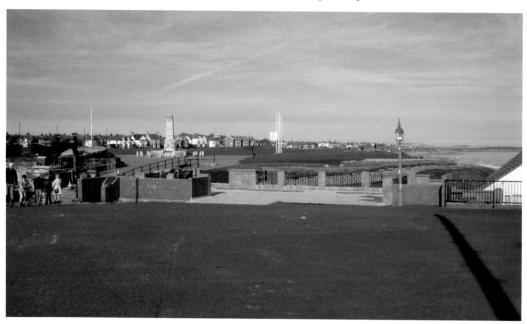

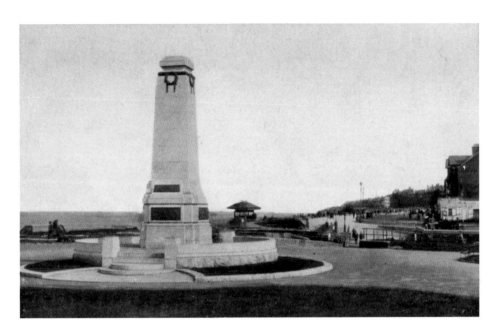

The War Memorial

The Cenotaph was unveiled by the Duke of Northumberland in 1922 in memory of the fallen from the First World War. Names of servicemen lost in the Second World War were added later, and each Remembrance Sunday a service is held, together with the laying of wreaths. The postcard dates from around 1930 and shows an ornate shelter on the Promenade above Watts Slope, close to where the present *Sandcastles* seat sculptures now stand. A ring of bollards were erected some years later, originally with decorative chains between.

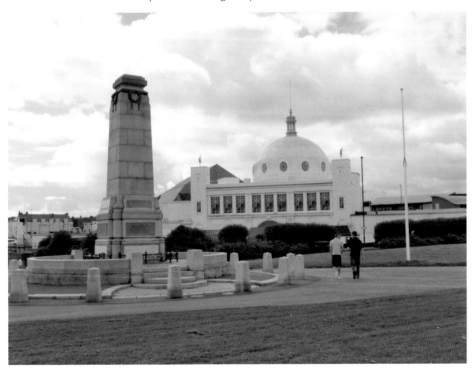

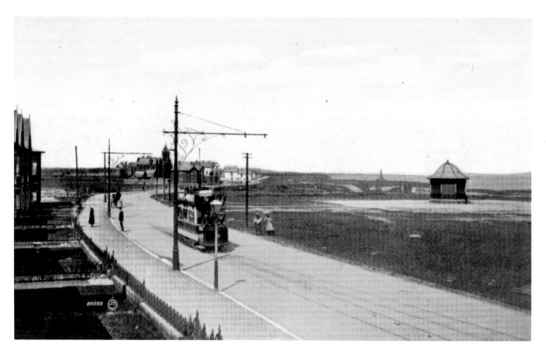

Tram Terminus

The trams terminated at the bandstand from 1904 to 1931. The present bus stop is still referred to as the 'Bandstand stop' even though the bandstand was removed many years ago. The first smaller bandstand was moved and re-sited overlooking Brown's Bay, above Table Rocks. It was replaced by a larger bandstand to commemorate the coronation of King George V in 1911. The picture was taken from Povesi's Café & Restaurant, opened in 1905 on the corner of Marine Drive. It was later renamed the Grosvenor Café.

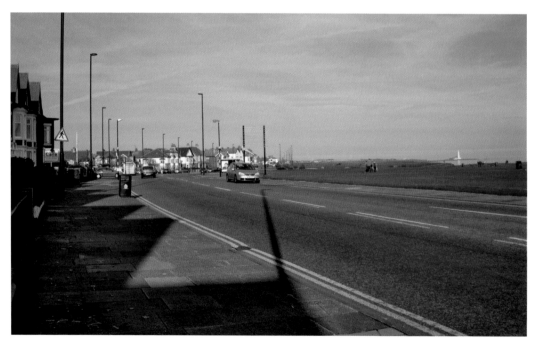

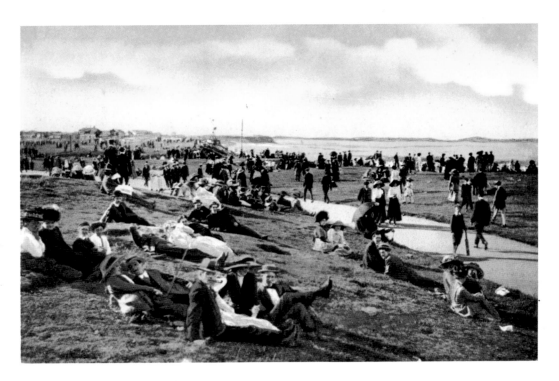

The Links Looking North, c. 1913

The Links was badly despoiled by coal and ironstone mining up until 1882. The Links could also be used for grazing cattle and horses by farmers from Whitley Park Farm, just south of the Convalescent Home, and Hartley South Farm on the site of the cemetery. It is said that the Links was levelled by the Whitley Bay Golf Club, which formed in 1890. Over the last century they have largely been used for recreation purposes, as open spaces with few buildings erected on them. A miniature golf course still operates on the Links today.

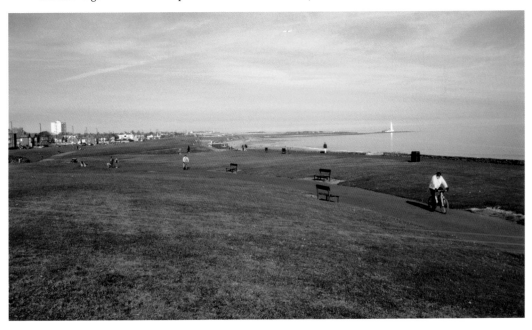

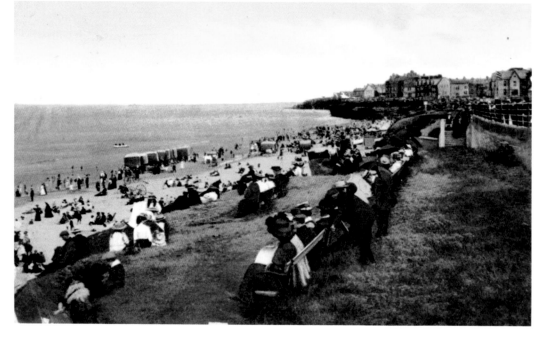

The Sands Looking South

The postcard is dated 14 September 1910 and was sent to Miss Hedley in Wylam from Winnie. She said, 'I am having a lovely time down here I am coming home on Saturday worst luck'. The bathing machines seem to be in use at the time, and a horse is visible on the beach, presumably employed to move them to and from the water. Everyone seems to be well-covered and, despite the big hats, some also have parasols to shelter from the sun. The Northern Lower Promenade was built a few years later in 1914.

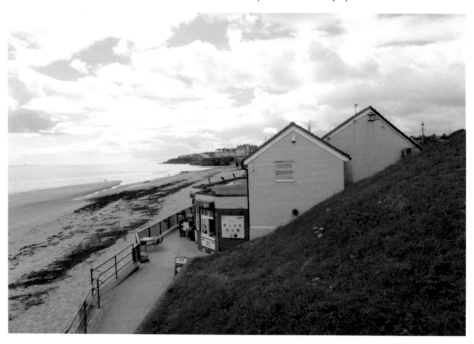

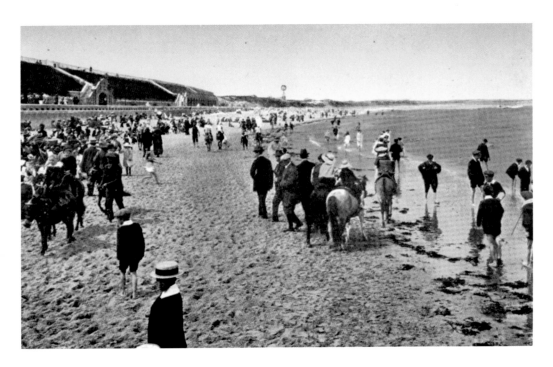

The Sands from Beach Looking North

The picture probably dates from around 1914, the year when the Northern Lower Promenade was completed, as it looks very new and only seems to extend to the Panama Dip area. It was extended further north to Briardene in 1926. On the beach, the donkeys are very popular with the children. In the background the windmill used to draw seawater to the convalescent home is clearly visible, in a location close to where the Rendezvous Café is now. The Rendezvous Café was opened in 1949 and has changed little since.

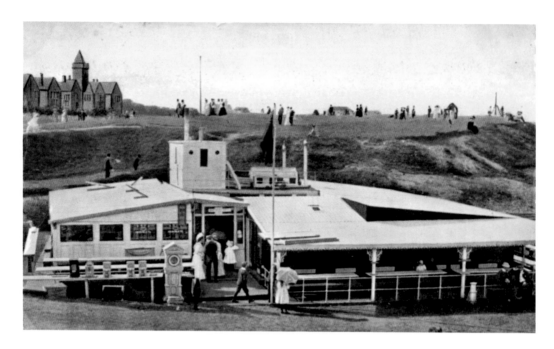

Panama House, *c.* 1909

Panama House Café was owned and developed in 1895 by Stephen Fry who had been a diver on the Panama Canal. Some claim the central part came from a wrecked vessel named *Panama* – the café did include a lot of nautical features. Stephen Fry died in 1912 and the café was taken over by the council and leased out. It burnt down in 1945 but was replaced by a smaller café later. It survived until the 1990s, and although gone, the name still lives on in the Panama Dip Gardens and the Panama Swimming Club.

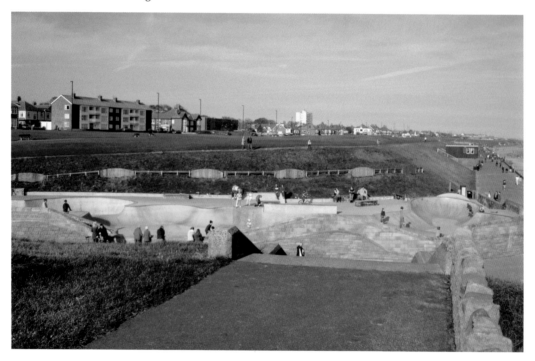

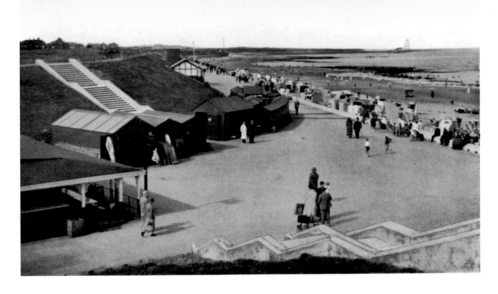

Promenade & Sands

Visible on the left is the canopy of the Panama House Café, around 1938. A number of buildings used for hiring tents and deckchairs have been erected to the back of the Northern Lower Promenade. The tents and deckchairs replaced the bathing machines on the beach. During the Second World War there was no access to the beach for the public, and a lot of buildings, including the beach chalets, were removed. In recent years, a new skateboard park was built on the site. This has proved very popular with skateboarders, and children on bikes and scooters.

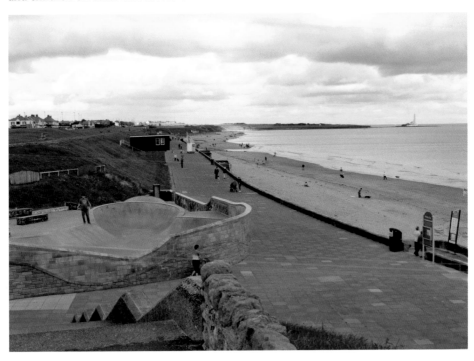

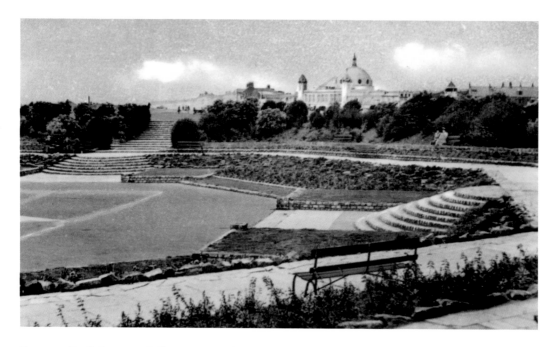

Panama Dip & Empress Ballroom, *c.* 1938

The Panama Dip was planned in 1933 to provide work for the unemployed. It was laid out as gardens surrounding a bandstand that backed onto the Panama House Café. The bricks used for the steps were taken up from the roadway when the tramlines were removed. Temporary seating could be erected in the central section during concerts. Following the war, the bandstand was replaced by a former fountain in memory of Doris Ewbank and other Civil Defence workers; the dedication stone can still be seen.

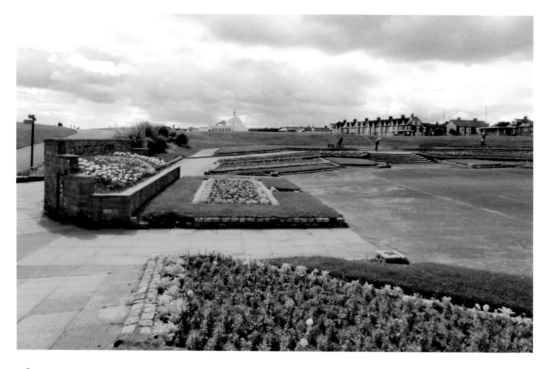

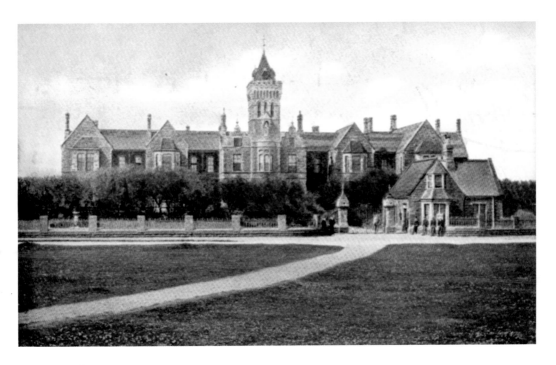

Convalescent Home, c. 1909

The Prudhoe Convalescent Home, designed by Thomas Oliver, was built in 1869 following public subscription as a memorial to the 4th Duke of Northumberland (also known as the Baron of Prudhoe Castle) who died in 1865. It was operated by Newcastle Infirmary, and the Convalescent Society of Northumberland & Durham. It housed sixty-five male and twenty-five female deserving poor, nominated by the charity. It remained open until 1959, when it was bought by the council. A new leisure pool was opened on the site in 1974.

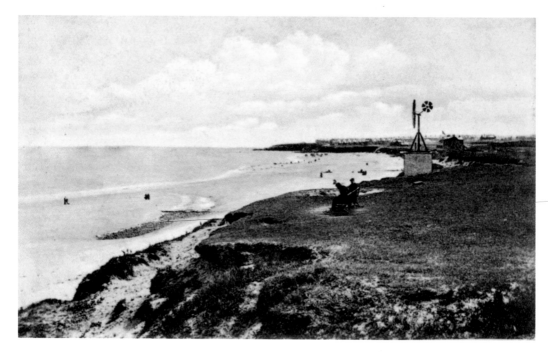

Golf Links Windmill

The postcard of the windmill on the Golf Links is dated 1905. At that time golf was being played on the Links, with Whitley Bay Golf Club, established in 1890, being responsible for restoring parts of the despoiled Links. The golf course moved inland away from the Links in 1906, but miniature golf is still found north of Briardene. The windmill was used to raise seawater, which was piped to the Convalescent Home to be used for health-giving saltwater baths. The Rendezvous Café, opened in 1949, is close to the site of the windmill.

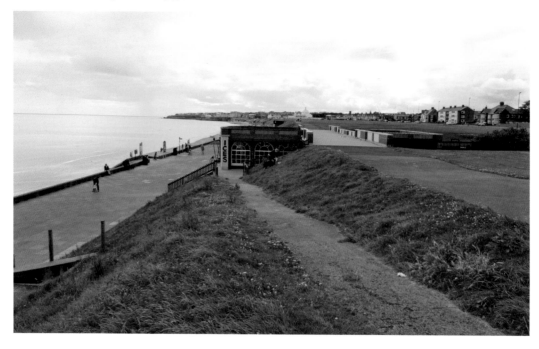

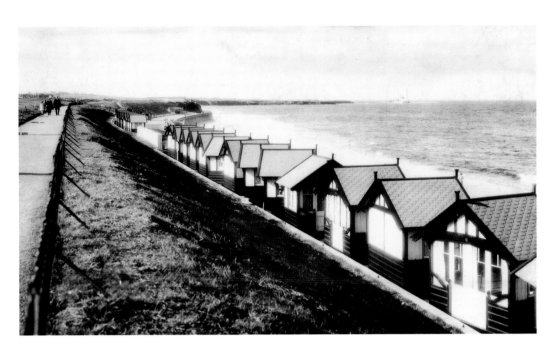

The Chalets, North Promenade

The postcard dates from around 1938 and shows the twenty-five original beach chalets, built in 1936 by Mr Kirsop and sold to the council that year. They were not used for long and were requisitioned by the authorities during the war, when the beaches were out of bounds to the public. They were taken down some time before 1955 and were eventually replaced in 1959. They survived until 1990, when they were removed. They were designed on wheels that allowed them to move to follow the sun; the metal tracks can still be seen on the bases.

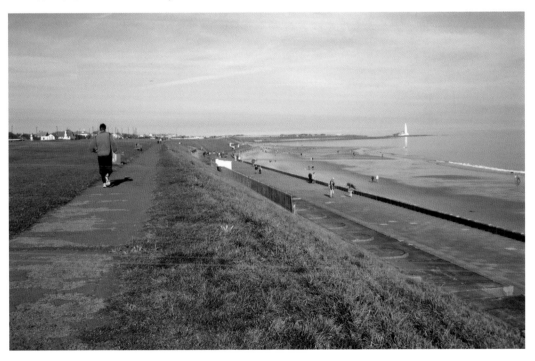

Briardene

The Briardene is an attractive valley either side of the main Links road. The road was built over the stream using a bridge in 1840 and became a toll road to the north until 1894. On the Ordnance Survey Map of 1896, the Briardene is culverted, and the building beside it is called the Culvert Inn. By 1904 the building had changed its name to the Briar Dene Hotel. Major sewage works were undertaken at the mouth of the Briardene in the 1980s, including an overflow pipe out into the sea. Landscaping included the provision of a new footbridge.

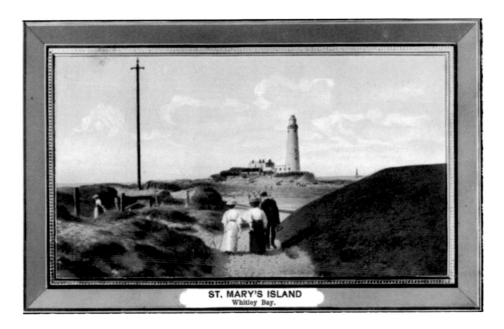

ST. MARY'S ISLAND
Whitley Bay.

St Mary's Island

St Mary's Island, also known as Bates Island, was named after St Mary's chapel, which had previously existed on the island. The lighthouse on the island was opened in 1898 to replace the lighthouse at Tynemouth Castle. It was in use until 1984 and was bought by North Tyneside Council in 1986. It has been a popular visitor and education centre since then. Michael Curry, who was found guilty of murdering the landlord of a nearby inn in 1739, was hanged and his body placed in a gibbet here at 'Curry's Point'.

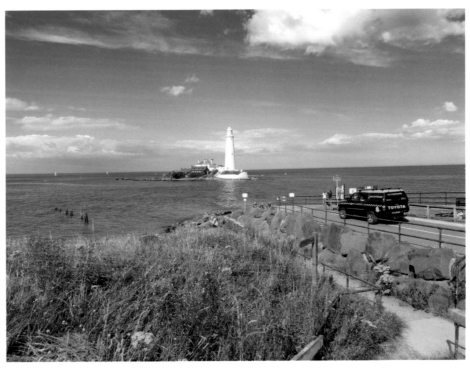

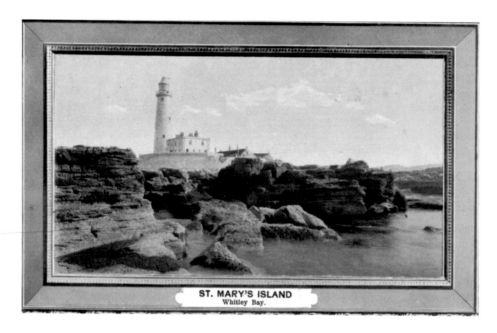

ST. MARY'S ISLAND
Whitley Bay.

St Mary's Island from the North

This is an unusual view of the lighthouse, as most are shown from the other side. This side of the island is very popular with divers, who can explore a number of shipwrecks in the area. The island is cut off by the tides twice a day. In 1862 the Ewen family opened an inn called the Freemasons Arms, or Square & Compass, on the island. This led to problems with the police, and the Ewens were evicted in 1895 when they fell out with the landowner, Lord Hastings. The cottages were used as a café for some time but are now in private ownership.

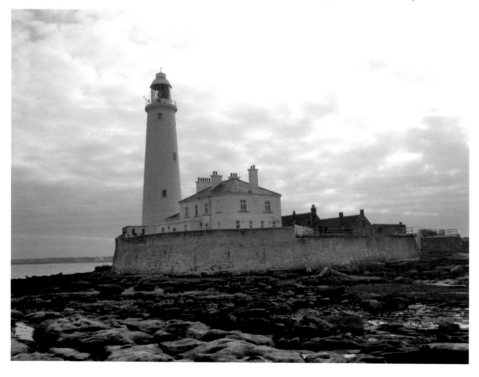

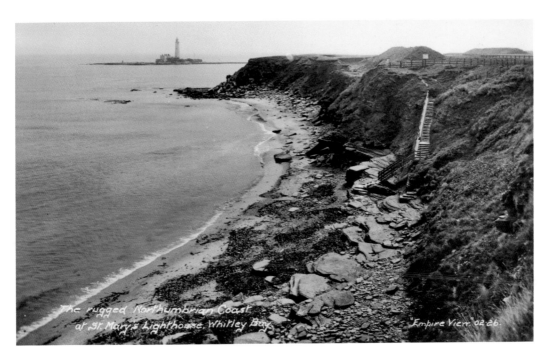

Rugged Northumberland Coast

This view of the rugged Northumberland Coast is captured from the cliffs just south of the caravan park at Old Hartley. St Mary's Island is in the distance. This part of the coastline will be familiar with visitors to Newcastle Airport, as most pilots arriving from the south or east use St Mary's Island as a guidepost before turning west towards the airport. The headland in front of St Mary's has the remains of a collapsed wartime pillbox on the beach following the erosion of the cliff. The mounds on the clifftops are also wartime shooting butts.

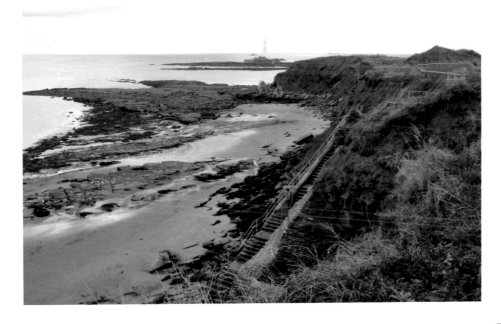

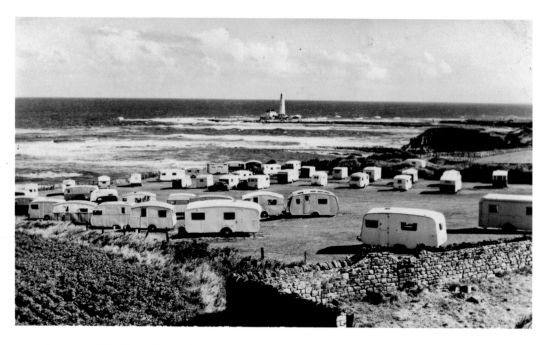

Caravan Club Site, Old Hartley

The Caravan Club at Hartley has been a long established site, as seen in around 1955. Its popularity has not diminished since, as the site affords open views over the coastline with St Mary's Lighthouse as a major attraction. Behind the site is Fort House, an unusual building built during the First World War and now listed. It was linked to a major underground complex of buildings on the adjoining headland, and was built as part of the Roberts Battery. The old water tower behind the Delaval Arms is also a reminder of that period.

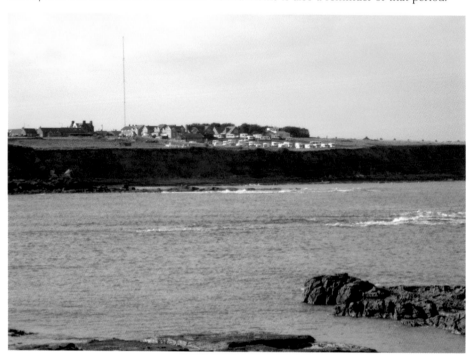

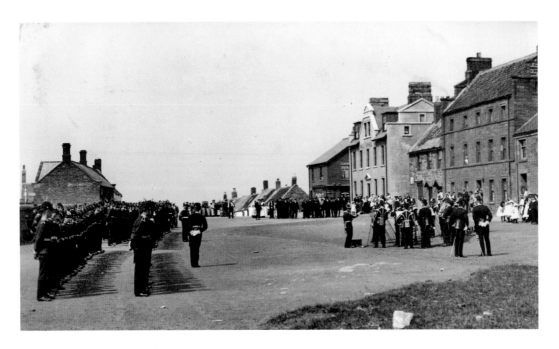

Military Parade, Old Hartley

The military had a base in the Seaton Sluice area and at Seaton Delaval Hall for some years before the First World War. This postcard is dated 26 July 1911 and shows a military parade in the main street of Old Hartley, with the Delaval Arms in the background beside a terrace of buildings, including Manor House. The building on the left may be linked to Hartley East Farm. There is no record on the card to say whether this was a special occasion, but it may have been linked to a royal celebration. Feathers Caravan Park was built on an Army camp.

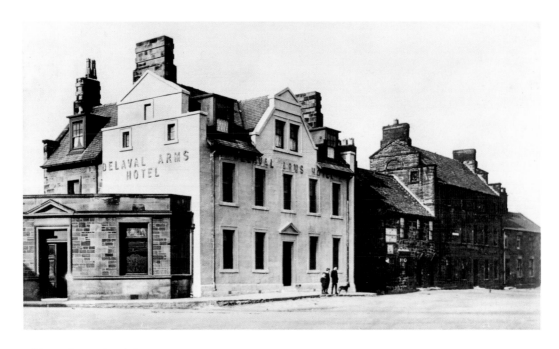

Old Hartley, Delaval Arms

The postcard of the Delaval Arms Hotel was sent to Master John l. D. Oakley in London on 15 February 1915 by his father with the following message: 'Dear John, Daddy often passes these houses. A lot of soldiers live there now. I hope you are taking care of your railway book. Aren't there lots of Puffer trains in it? Take care of your mother. Give my love to all. Daddy.' The Army was still based in the area after the start of the First World War, and the card was probably sent by one of the soldiers keeping in touch with his family.

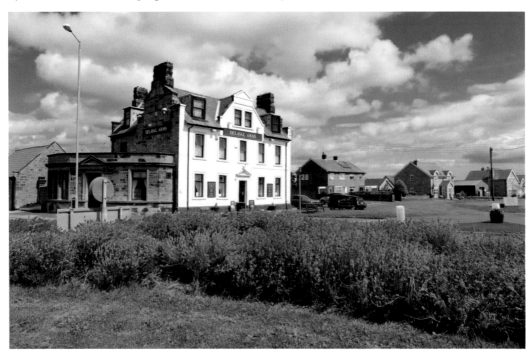

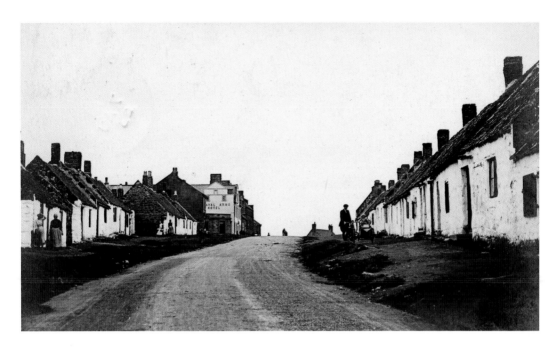

Old Hartley Looking East

Around 1923, the village of Old Hartley was essentially one street with buildings either side, leading from Hartley Lane up the hill to cross the road between Whitley Bay and Blyth. The Delaval Hotel is seen beyond, opposite Hartley East Farm. There were also a few buildings over the ridge fronting onto a small village green. The man on the right is proudly showing off his motorbike, and a child is sitting in the sidecar. A number of women outside the whitewashed cottages are also keeping an eye on the photographer.

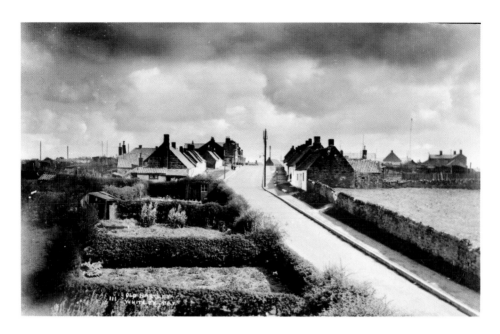

Old Hartley from Hartley Lane

This picture from around 1930 was taken from the railway line that crossed over Hartley Lane, forming part of the Collywell Bay branch line of the North Eastern Railway (NER). It was constructed before 1914, and when the First World War intervened the track was removed. Temporary tracks were installed later, but the line was abandoned in 1931. It terminated at Collywell Bay station and was built to serve the potential seaside resort of Seaton Sluice. The remains of the southern railway bridge abutment can still be seen and the trackbed extends south.

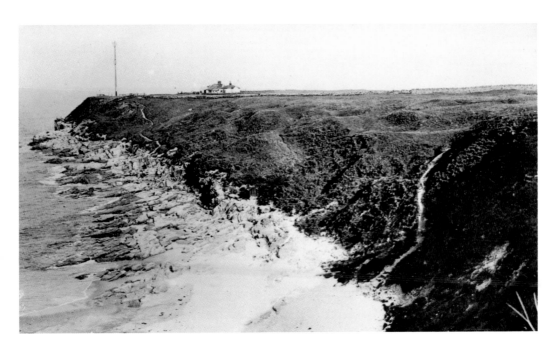

Collywell Bay & Crag Cottage

The buildings are referred to as Crag Cottage, but on the Ordnance Survey Map of 1922 they are referred to as Crag Point and are situated close to a beacon for a measured mile. There was another beacon further inland, near the railway line, and two similar beacons one nautical mile to the south, between Hartley and Whitley, near the cemetery. Shipbuilders from the Tyne used the measured mile to check the speed of vessels in trials. The road down to Collywell Bay was built as part of works for the sea defences completed in 1981.

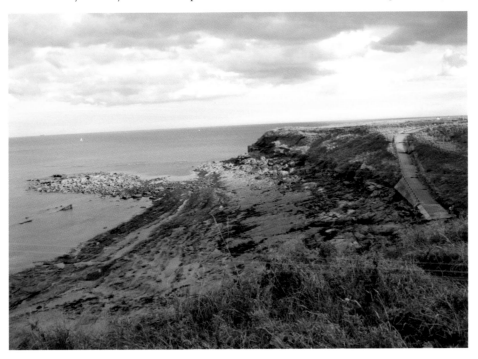

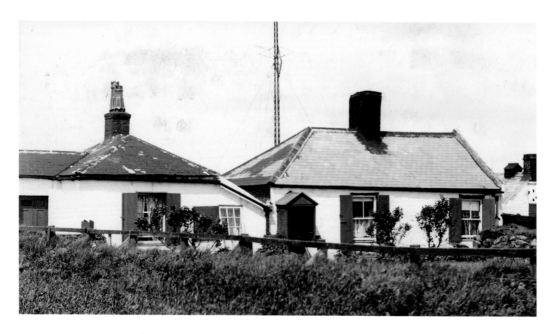

Crag Cottage, Seaton Sluice

Crag Cottage, dating from 1832, together with its signalling masts, was the first coastguard station in the area. There is no trace of the buildings, masts or the measured-mile beacon on the headland today. Immediately inland is the extensive underground Robert's Battery, built 1917–21. This battery and an identical one at Marden in Sunderland (Kitchener Battery) both had 12-inch gun turrets erected on them, taken from the 1898 HMS *Illustrious*. They protected the mouth of the Tyne, with an observation post at Percy Gardens in Tynemouth.

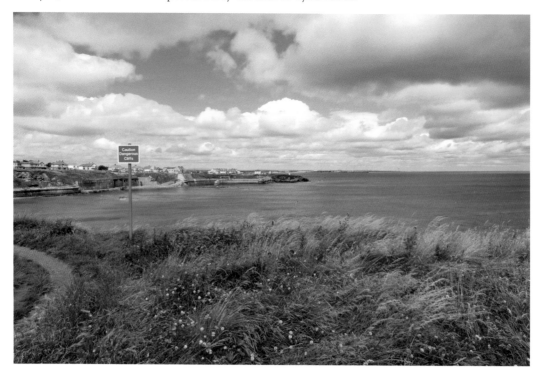

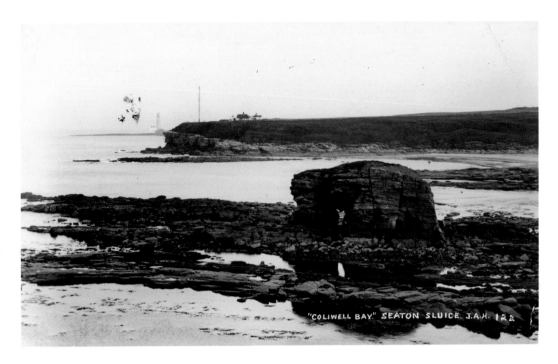

Collywell Bay, Seaton Sluice

In the background are Crag Cottages, the beacon and St Mary's Lighthouse beyond. The sea stack in the foreground was known locally as Charley's Garden. It was named after a local man Charles Dockwray, who was said to have cultivated the top as a garden for growing vegetables. At the time of the picture (around 1920) there was an arch on the stack and grass on the top. Now, however, the arch has gone, as has any vegetation on the much smaller stack. It is very well used by seabirds including cormorants.

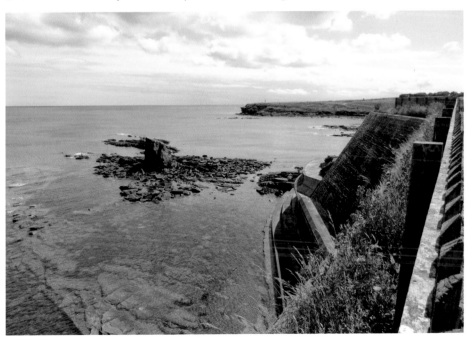

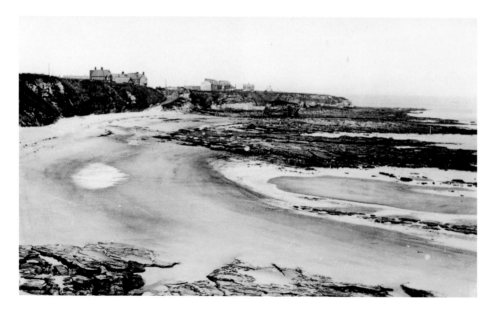

The Bay, Seaton Sluice

This view of Seaton Sluice is taken across Collywell Bay in 1917, from west of Crag Cottage. Beyond Charley's Garden, the Watch House and a detached house on Rocky Island can be seen. Further to the west is West Terrace, beside the Kings Arms, with another terrace of houses at right angles, now on Albert Road. Beside that is the present scout hall, built in 1897 as the Diamond Jubilee Institute (for Queen Victoria's Diamond Jubilee), and a large house overlooking the bay. A major 'sea wall' was built in 1981 to protect the houses on Collywell Bay Road.

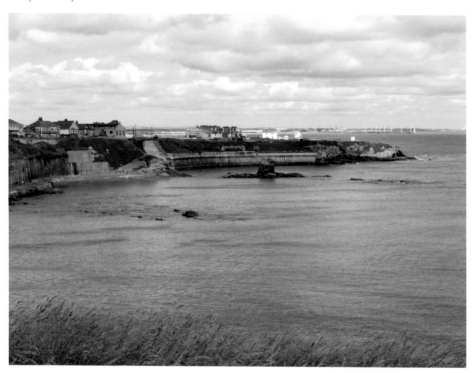

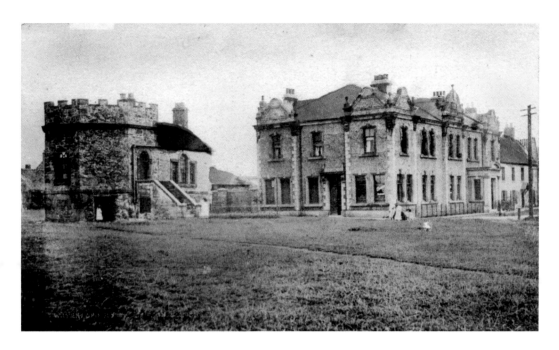

Waterford Hotel, Seaton Sluice

The postcard of the Waterford Hotel dates from 1905 and also shows the unusual octagonal building beside it that was originally built in the 1700s as a customs office. The Waterford Hotel dates from 1899 and replaced an earlier hotel. It was named after Susanna of Ford Castle, Marchioness of Waterford, and Lord Delaval's granddaughter, who inherited the glassworks in 1822. The Waterford Arms is still a hotel and restaurant. The Octagon was once used as reading rooms by glassworks employees and is now a private house.

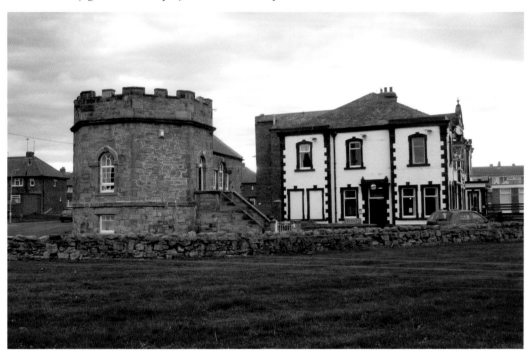

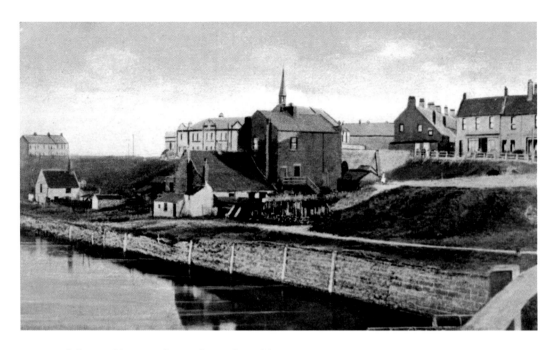

Seaton Sluice Looking South-East from the Bridge

This view from around 1910 looks towards the old Melton Constable Inn, built into the bank of the harbour in 1839. It also had a school and butcher's shop. It was named after the Astley family seat in Norfolk. Rhoda Delaval married Edward Astley in 1751, and they inherited Seaton Delaval Hall in 1814. John Willie Gibson's house is on the low level. The spire above the Melton Constable is from the original St Paul's church. The shop in the terrace on the right was recently built on part of Glasshouse Square.

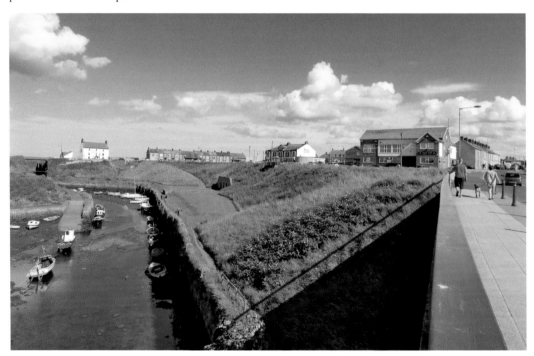

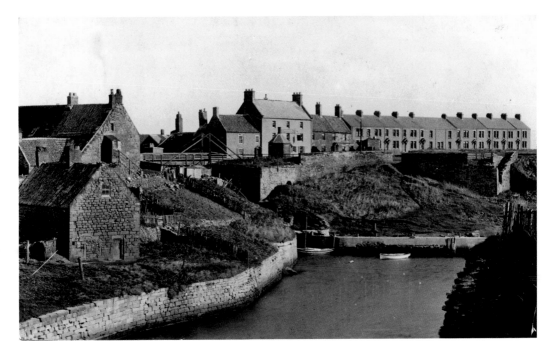

Seaton Sluice from Sandy Island

This view was taken from Sandy Island, looking south towards the Cut over the harbour, and dates from around 1912. Beyond the two cottages on Rocky Island, the swing bridge over the Cut is visible, with the Kings Head behind and West Terrace beyond. The little hexagonal building to the right of the bridge was the Pilot's House, erected in 1764 and said to be the smallest in the country. The harbour was very busy exporting coal, bottles and other goods until 1862 – the date of the disaster at Hartley Pit, which led to the closure of the colliery.

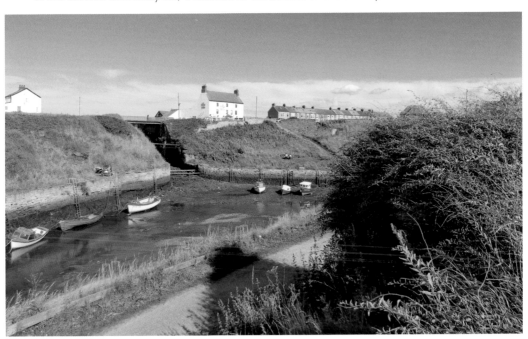

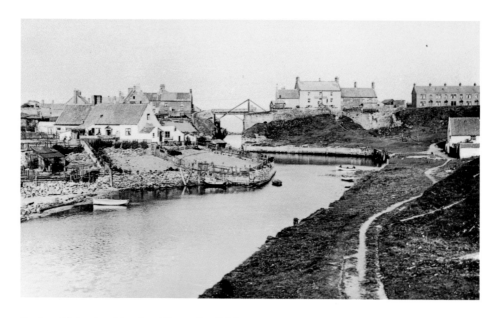

Seaton Sluice Looking East from the Bridge

Dating from around 1920, the view taken from Seaton Sluice Bridge looks over Sandy Island towards the Cut, which separates Rocky Island from the mainland close to the Kings Head Inn, with buildings either side of it. At that time there were still cottages on Sandy Island as well as Rocky Island. In the 1901 Census there were sixteen cottages on Rocky Island with sixty-three residents, including a coal miner, a hawker of fish, a coastguard, a tailor, a teacher and a blacksmith. All the houses except the coastguard cottages were demolished in the late 1950s.

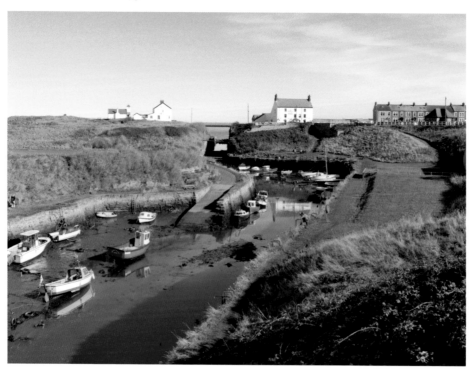

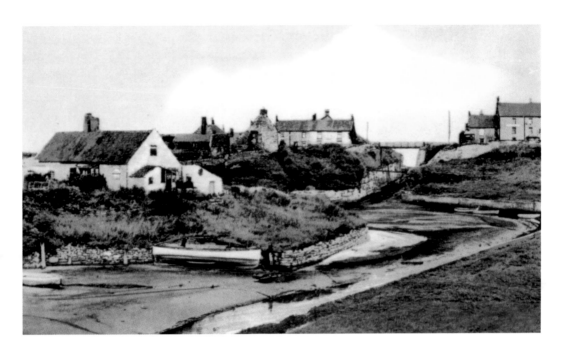

The Sluice, Seaton Sluice

Seaton Sluice got its name between 1660 and 1690 when Sir Ralph Delaval developed the harbour and erected the sluice gates across the Seaton Burn to hold back the water before it was discharged to flush away the sediment building up in the harbour. This allowed vessels to be able to enter the harbour to load up coal and other exports. At low tide you can see how much sediment still collects in the present harbour, but as it is only used by fishermen and pleasure boats this does not lead to many problems.

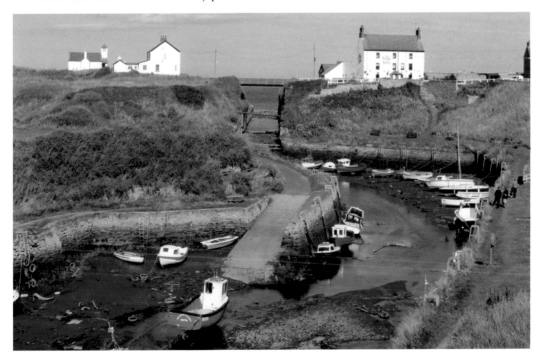

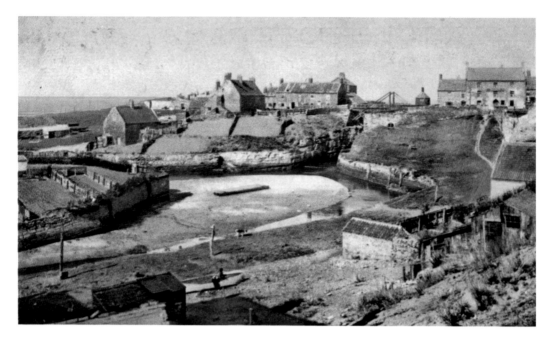

Whitley Bay, Seaton Sluice

The postcard is date stamped 30 August 1904. It looks north-east across the harbour towards Rocky Island. The Kings Arms Inn is on the top right, beside the Pilot's House, with the swing bridge over the Cut beyond. The harbour was originally known as Hartley Pans, when it was being used to produce salt, using salt pans. Saltwater was boiled by means of a coal fire under the metal pan, and the salt was extracted. Salt was exported from the harbour for many years together with coal, copperas and later bottles. Seaton Sluice was once part of Whitley Bay Council.

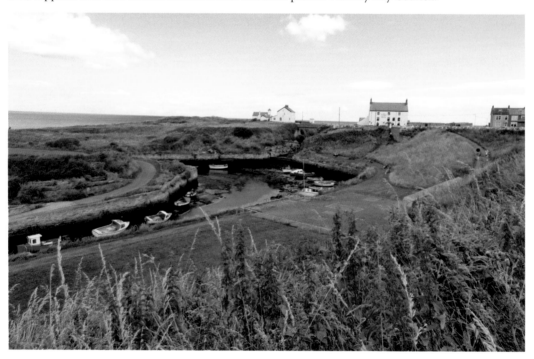

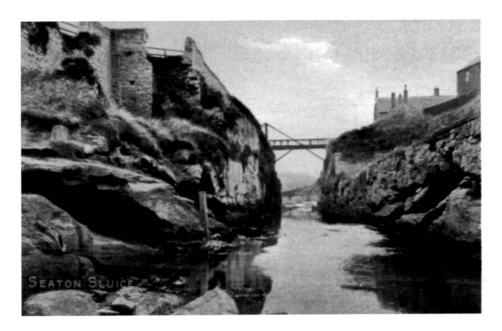

Seaton Sluice Cut

The Cut or Gut, seen here before 1905, was constructed in 1764, on the orders of John Hussey Delaval and his brother Thomas, to provide an all-weather dock to enable ships to be loaded at all times without being dependant on tides or weather. It was cut out of solid rock and was 270 metres (890 feet) long, 9 metres (30 feet) wide and 15 metres (50 feet) deep. The first ship to sail out carrying 270 tons of coal was the *Warkworth*. Timbers were installed at either end to keep the water in at low tide. It was last used in 1862 for exporting coal.

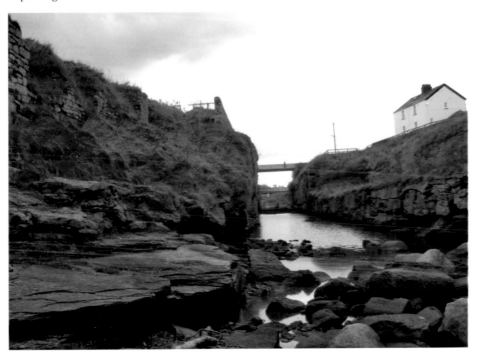

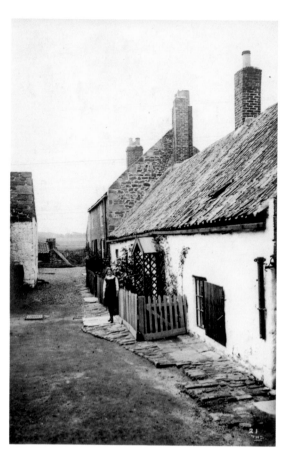

A Bit of Old Seaton Sluice

This view is thought to have been captured on Rocky Island around 1930. In 1901 there were sixteen cottages on the island, but now the only buildings on the island are the two former coastguard houses, built in 1888, the Seaton Sluice Voluntary Life Saving Company Watch House, formed in 1876 (pictured below), and a lookout hut. Some people spent their entire lives living on the island. One was Samuel Elder, born in 1827, who went on to have fourteen children. Some were more adventurous and moved to Sandy Island or across the bridge to the mainland.

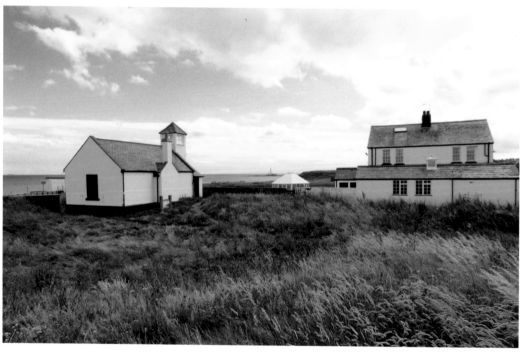

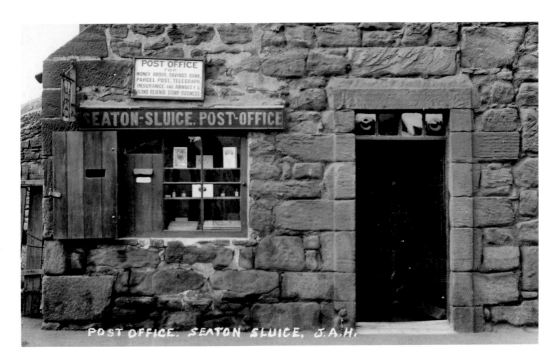

Post Office, Seaton Sluice

The post office, seen here in 1912, was located on the gable of Delaval Street, close to Short Street and Long Street on the Ordnance Survey Map of 1897. The streets had been renamed Hussey Street and John Street after John Hussey Delaval by 1922. Another post office is shown on the Ordnance Survey Map of 1922, located to the south of the present St Paul's church. The current post office is in a shop on Beresford Street, which now continues in a straight line to the present bridge erected in 1968; the old bridge was further west and at a lower level.

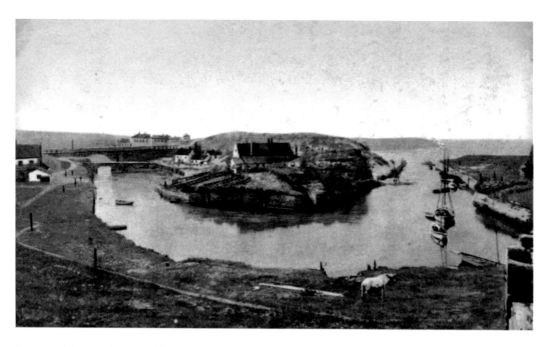

Seaton Sluice Harbour Looking West, c. 1906

The postcard looks west from outside the Kings Arms Inn. Two bridges can be seen crossing the Seaton Burn; the nearer, lower bridge is the oldest, dating back to the 1700s, and the higher bridge was built in 1894. The cottages beside the old bridge on Sandy Island were occupied by the Crane family before they were demolished around 1908. The raised areas behind are the ballast hills, made up from ships ballast (chalk, sand and flint) deposited on the land over the years before the ships were loaded with coal.

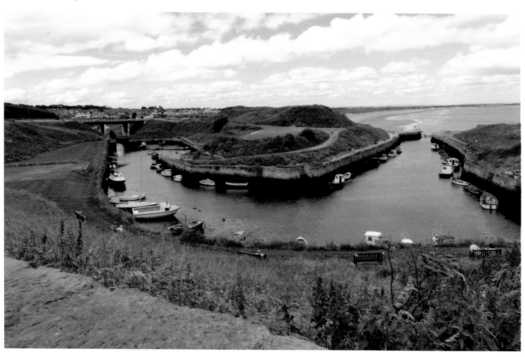

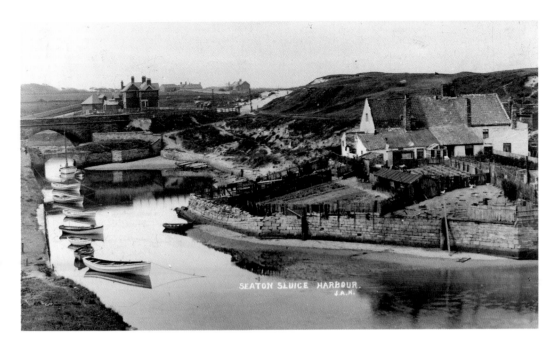

Seaton Sluice Harbour & Sandy Island

This view dates from around 1920 and shows the new Melton Constable Pub, built in 1908, in the distance beyond the bridge. The cottages in the foreground are still occupied, but the cottages beside the old bridge have been demolished. Chickens can be seen in the allotment gardens to the rear. George and Linda Elder moved to one of the cottages from Rocky Island, and Linda set up a tea room for visitors to Seaton Sluice – an early tourist attraction for visitors coming by boat from the Tyne. All buildings on Sandy Island, not really an island, have gone.

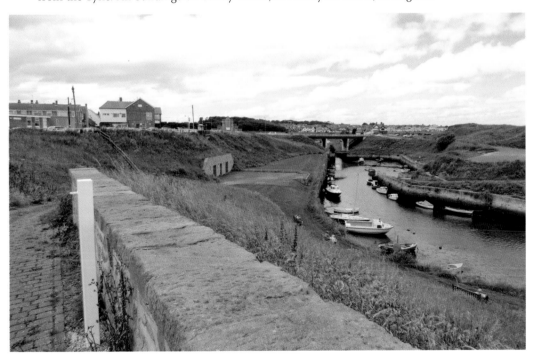

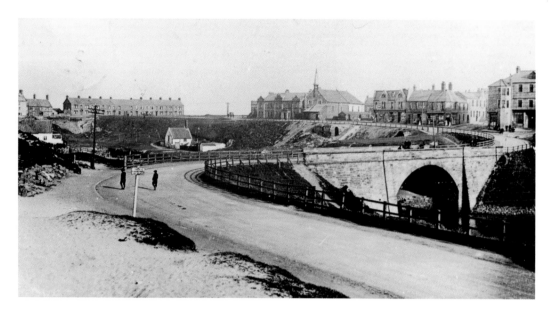

Seaton Sluice Bridge from the West

The bridge, built in 1894, is shown here before 1922 – the date on the postcard. The spire of St Paul's church can be seen beyond the bridge. This was a remarkable building and was built before 1800 as a brewery. When it fell out of use, the back part, rendered white, was converted in the 1850s to be used by the Wesleyans. In 1870, the front part, facing the harbour, became St Paul's church. The building was demolished in 1962 and the former Ochiltree Hall, built in 1914 in memory of John Ochiltree, became St Paul's church.

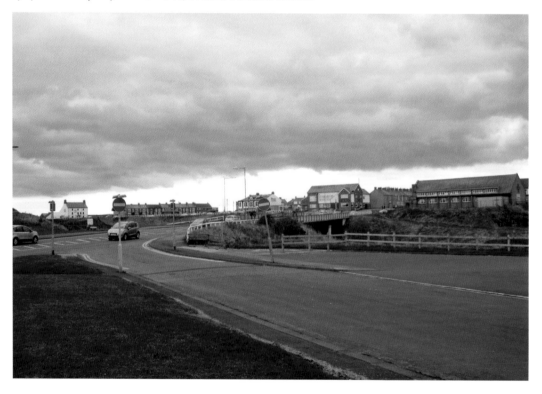

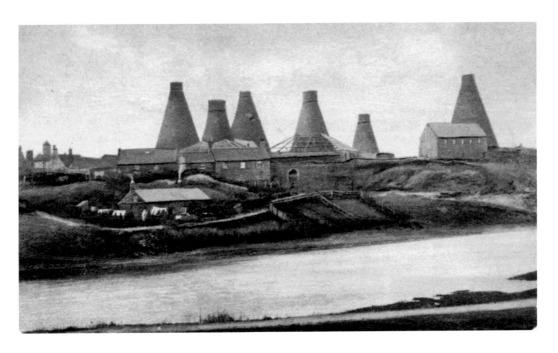

Bottle Works, Seaton Sluice

The engineer Thomas Delaval and his brother Lord John Delaval developed the Royal Hartley Bottle Works from 1763, to take advantage of the available materials close to the site, namely coal, sea sand, kelp and clay. A copperas works was also established behind the Waterford Arms, to provide a glass colouring agent; it was derived from pyrites found in the coal seams. The copperas works closed in 1828. To supply ships for the new harbour, Lord Delaval also opened a small shipbuilding yard on the Sandy Island side of the harbour, which closed before 1812.

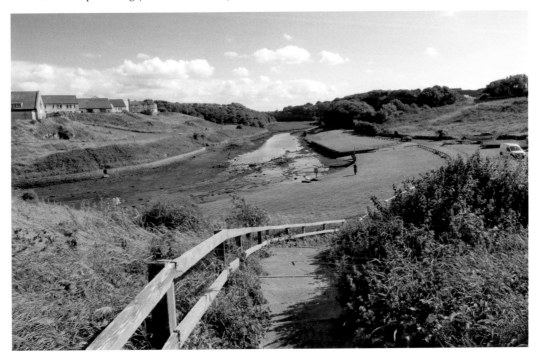

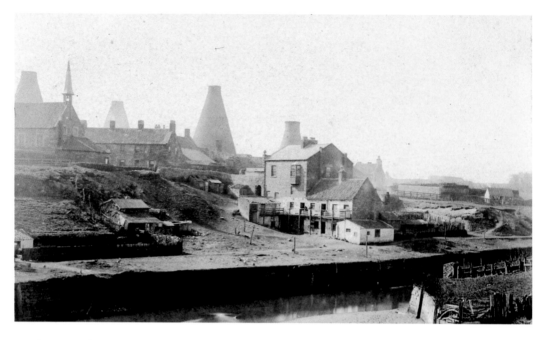

Bottle Works from the Harbour

In 1764 two rectangular buildings were erected and added to by three more efficient round cone structures in 1778, 1782 and 1788. A further three slightly smaller ones were built after 1822. They were all given a name: Success, Waterford, Byas, Gallaghan, Charlotte and Hartley. The works closed in 1870 and the cones were demolished in 1896. The works, glasshouses and storage cellars were linked to the harbour by a system of underground tunnels and wagon ways. 'Bottle sloops' were used to transport bottles from the harbour.

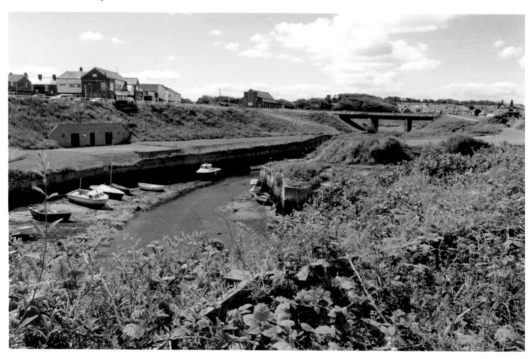

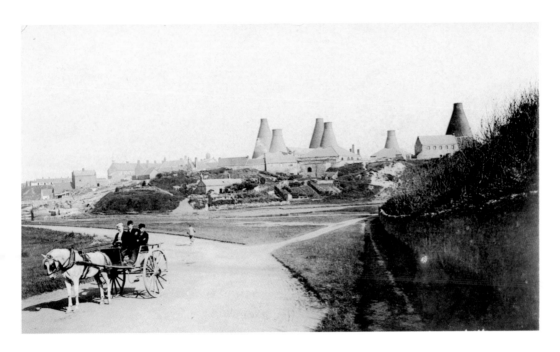

Bottle Works from the North

The bottle works, known as 'The City', was situated on the south side of the Seaton Burn to the west of the Bridge, on the land now occupied by St Paul's church and Ryton and Bywell Terraces. The housing and glasshouse offices nearby were built around Glasshouse Square, which backed onto Delaval Street, with Market Square beyond. The Methodist chapel linked to St Paul's fronted onto market square, as did the rear of the Waterford Hotel. The wall on the right is the boundary wall from Seaton Delaval Hall, which still remains today.

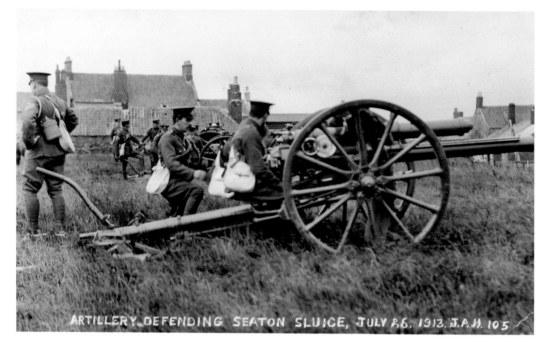

ARTILLERY DEFENDING SEATON SLUICE, JULY 26, 1913. J.A.H. 105

Seaton Sluice, 1913

These two photographs were taken by a well-known resident of Seaton Sluice, Jimmy Hutton, who put his initials J. A. H. on his pictures, with the exact date as well as a description. The artillery defending Seaton Sluice on 26 July 1913 is pictured behind the Kings Arms Inn, with buildings on Rocky Island to the right. '"P.M." Rally. Seaton Sluice Aug 4th 1913' presumably refers to a meeting of members of the Primitive Methodists, held on the ballast hills behind Sandy Island. The writer of the postcard refers to family members in the group.

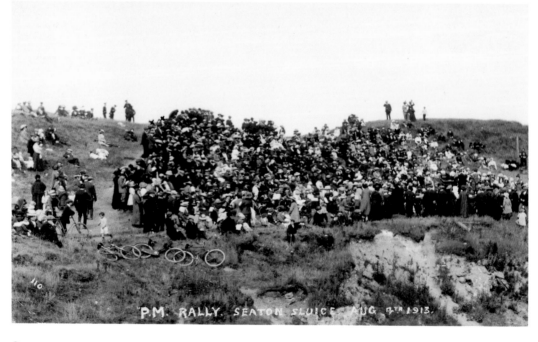

P.M. RALLY SEATON SLUICE AUG 4TH 1913.

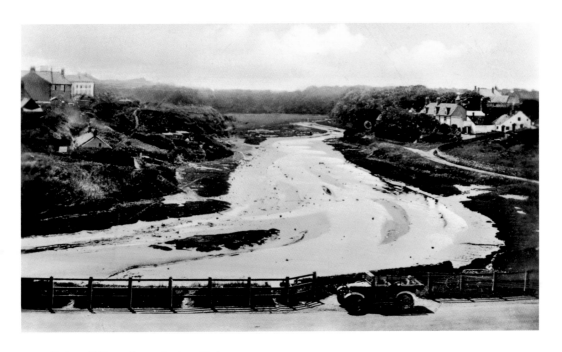

Holywell Dene from Seaton Sluice, *c.* 1920

This view is taken from just over the bridge, on the north side, looking west towards Holywell Dene over the floodplain of the Seaton Burn. On the left is a cottage, situated below what was the bottle works until the 1890s. It was situated just beside a ford across the burn, shown as in use on the Ordnance Survey Map of 1897. This may well be an ancient crossing point, as the boundary of the Seaton Delaval Hall estate wall follows a line to the west of the track from the ford as it goes uphill to the north close to Seaton Lodge, which is seen on the right.

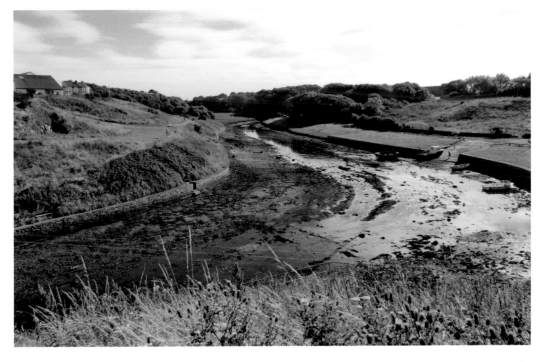

Seaton Lodge, Seaton Sluice

The white building to the right of the two eighteenth-century cottages that remain today is Seaton Lodge. It was built in 1670 by Thomas Harwood, a master mariner, and was a large Jacobean-style house with a thatched roof. It was bought by Sir Ralph Delaval in 1674; he moved out of his mansion house on the estate to live at Seaton Lodge in 1685. Samuel Peyps (1672), Secretary to the Admiralty, and the Scottish inventor James Wyatt (1768) are both said to have visited the Lodge. It was demolished in the 1960s.

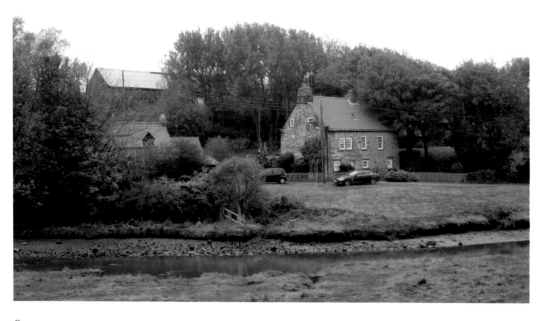

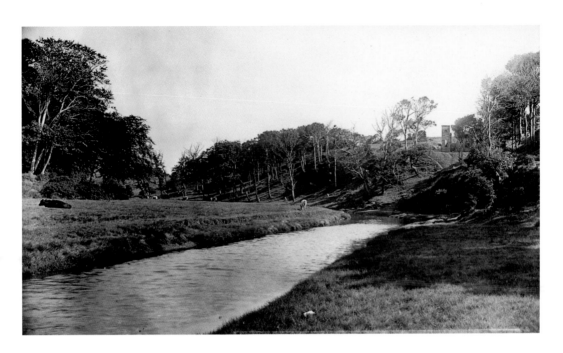

Holywell Dene & Starlight Castle, *c.* 1920
The view looks west along Holywell Dene from beyond Seaton Lodge. On the skyline to the right, among the trees, are the ruins of Starlight Castle. Just beyond the bend of the burn are the remains of a bridge abutment, which supported an old trestle bridge, built in 1784, which carried the wagon way from Hartley Hester Pit and others over Holywell Dene to the bottle works and harbour. The line of the wagon way still exists behind Starlight Castle and now forms part of the extensive footpath system in the area.

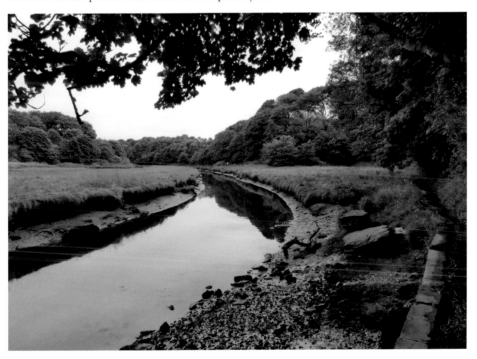

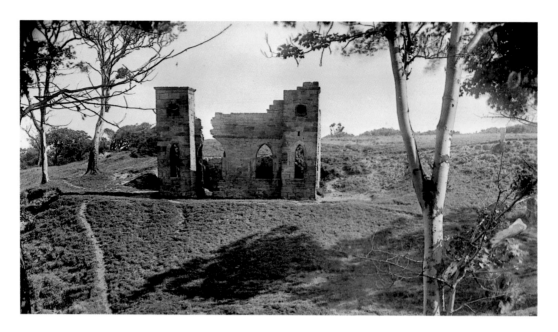

Starlight Castle, Seaton Sluice, *c.* 1920

Starlight Castle was a folly built in the 1760s by Sir Francis Blake Delaval to win a bet of 100 guineas with his friend the playwright Samuel Foot. To win the bet the castle had to be built in twenty-four hours – hence the name Starlight Castle, as it was built by the light of the stars. Sir Francis had arranged for a lot of it to be fabricated in advance but it was erected within the time and someone slept in it the following night. It was lived in until 1874. It has declined in size over the years, and now only part of one tower remains.

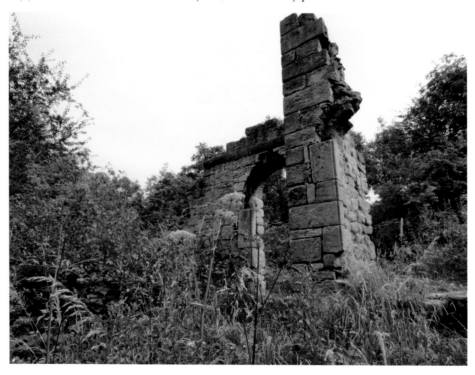

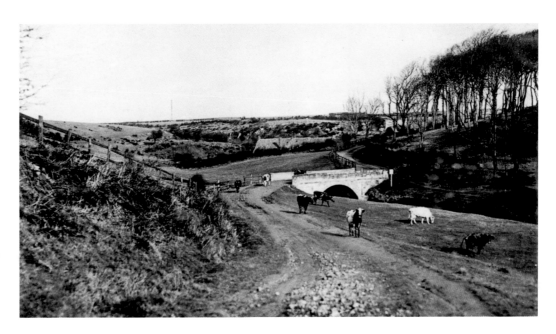

The Stone Bridge, Holywell Dene

This postcard is postmarked 1916 and shows the old stone bridge in Holywell Dene, which links Old Hartley to Holywell Village. Hartley West Farm is about 100 metres further up the slope. The building beyond the bridge is Grove Farm, farmed by William Lambert, which was demolished some time ago. The remains of the farm's foundations can still be seen down the slope from the present car park. There were numerous former pits around Holywell Dene, and two near this area were called the Hospital Pit and the June Pit.

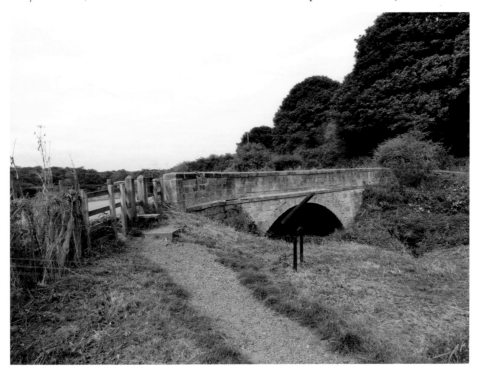

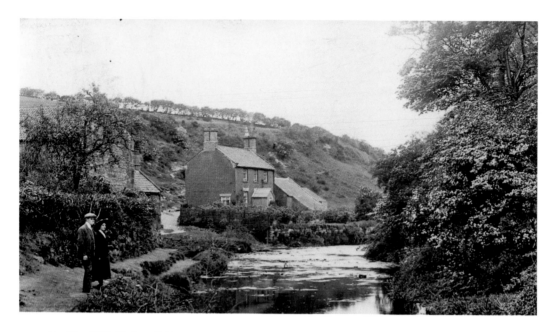

Hartley Mill, Holywell Dene

This picture dates from before 1920 and shows a couple standing in front of Hartley Corn Mill (1760–1920), which is partially hidden by the trees, with the mill cottages beyond. Today the only remaining evidence is part of the mill's rear wall, built into the bank, below a footpath leading up to Hartley West Farm. The stepping stones over the burn also survive. There was a long mill race cut into the bank to feed water to the mill, and this followed the north bank of the burn from a dam built close to the waterfall upstream.

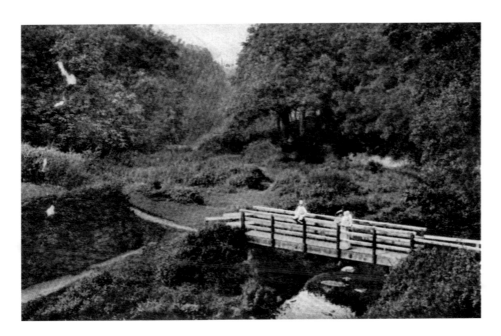

Holywell Dene, Engine House Bridge

This footbridge, seen here before 1905, led from the Old Engine, which stood at the top of a steep path up from Holywell Dene. A new bridge now occupies the same site. The engine was used to draw up coals from collieries in the area; the nearest one was called the Old Engine Pit and was sunk in 1753. Other pits nearby were Old Pits, Lume Pit, Lane Pit, Delaval Pit and Silver Hill Pit. The path up the north side of the Holywell Dene led directly to the settlement known as Silver Hill, which, as well as a pit, had a windmill from 1628 to the 1770s.

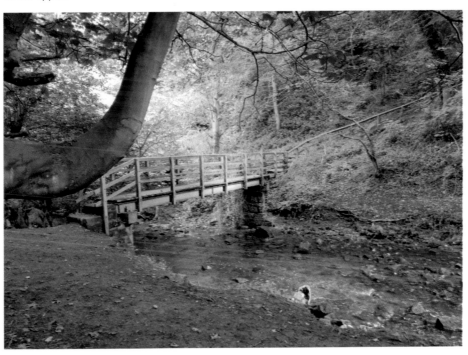

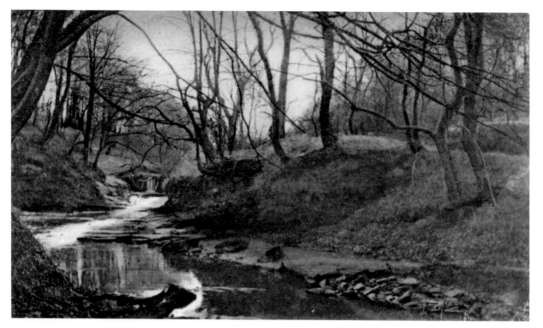

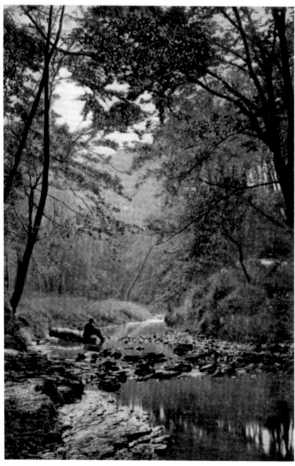

Holywell Dene, Near Whitley Bay
These two postcards, dating from before 1905 and 1907, show how attractive Holywell Dene was. What they do not show is that at one time nearly 200 people lived within the Dene itself, in mills, farmhouses and colliery rows. A famous resident was William Carr, known as the 'Hartley Sampson', who was born in 1756 at the Hartley Old Engine House. This gentle giant of a man is reputed to have lifted the blue stone (boundary marker) situated outside the Delaval Arms, as well as famously escaping from the press gangs.

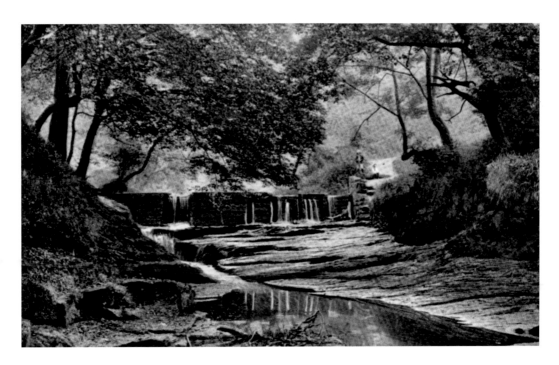

Waterfall, Holywell Dene

Just beyond the present waterfall, the Seaton Burn was dammed using timbers erected across the valley to hold back the water and to feed the mill race that started at this point. The picture, dating from before 1905, shows the dam and the stone walls erected either side to hold the timbers in place. The walls can still be seen today, as can sections of the mill race, but most of it was destroyed when a pipeline was built along the floor of the Dene in the mid-twentieth century.

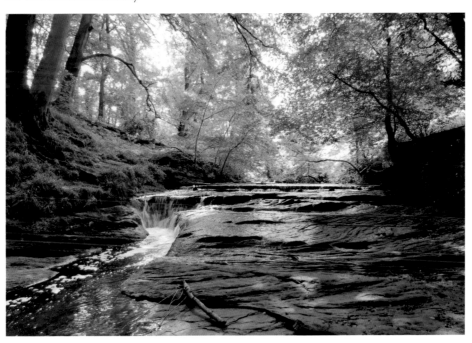

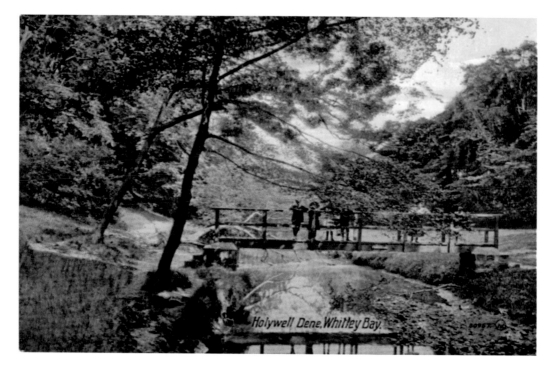

Holywell Dene, Whitley Bay
This footbridge lay upstream of the dam and linked Crow Hall Farm with the settlements in Holywell Dene, not far from where the Avenue branch line, now a major footpath link, was built in 1864. Near the bridge on the north side of Holywell Dene was a settlement known as Goulden's Hole, occupied by families working in the local pits including the Nightingale Pit (1799), the Engine Pit and the Fox Pit. In 1841 Goulden's Hole had fifty-three residents living in ten houses, but by 1861 it was deserted.

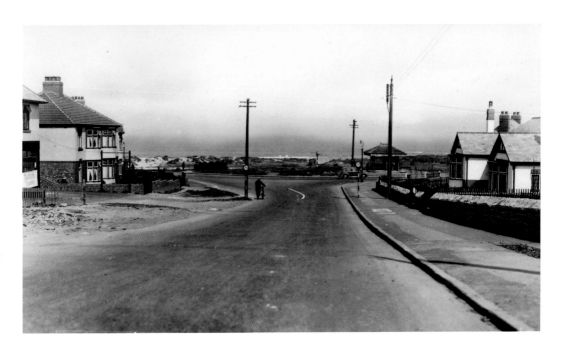

Fountain Head Bank, Seaton Sluice

Fountain Head is the name given to a small group of cottages on the side of the road leading from Seaton Sluice to Seaton Delaval Hall. The road follows the north boundary wall of the Seaton Delaval estate past Lookout Farm at the top of the bank. Inside the wall of the estate, adjoining the sea walk from the hall, is the derelict but impressive Mausoleum. It was built for John Delaval, the son and Heir to Lord John Delaval who died in 1775. As the Bishop of Durham demanded a large fee to consecrate the building, it was never used.

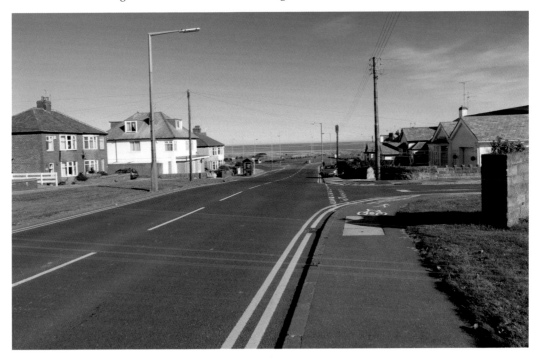

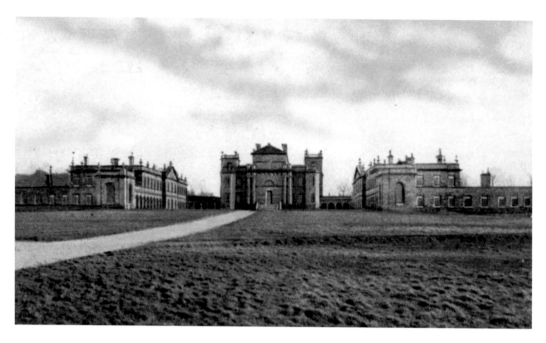

Seaton Delaval Hall, North Front, *c.* 1910

Seaton Delaval Hall was built between 1718 and 1728 for Admiral George Delaval, as a palace for his retirement, and was designed by John Vanbrugh. Sadly, neither lived to see the hall completed. Admiral George fell off his horse and was killed in 1723, just to the north-east of the Avenue and New Hartley road junction. The base of an obelisk records the location. Vanbrugh died in 1726. The hall was inherited by Sir George's nephew, Captain Francis Delaval, who completed it.

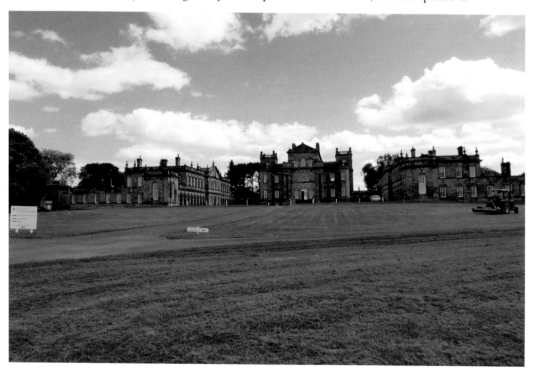

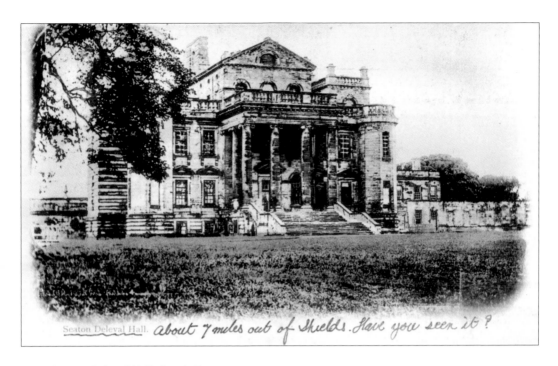

Seaton Deleval Hall. *about 7 miles out of Shields. Have you seen it?*

Seaton Delaval Hall, South Front

The south front is seen here before 1904 (above), and before 1914 (below). The hall was occupied for less than a century before a great fire in 1822, which destroyed a wing erected on the south-eastern side of the building and severely damaged the remainder of the main block. The building stood for over forty years without a roof on it. In the 1860s, Newcastle Architect John Dobson did some restoration work, which included the construction of a new roof. It stood for another 100 years before being restored as the present shell with replacement windows.

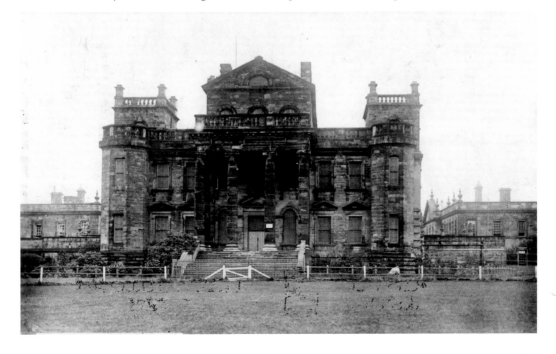

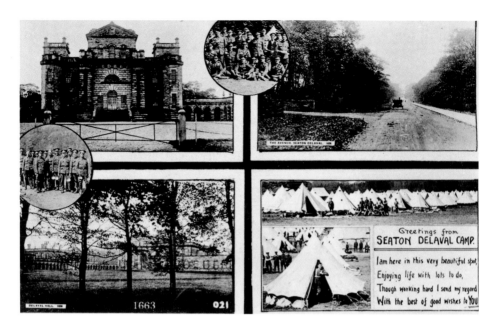

Seaton Delaval Camp in the First World War

This postcard was designed as a greetings card from Seaton Delaval Camp. It features happy soldiers camped in the fields around the Seaton Delaval Hall in 1914. 'D' Company of the 3rd Battalion, the Northumberland Volunteers, was based at Seaton Delaval for training. A camp was set up on the vicarage field for the Tyne Garrison, seen here, which were responsible for the defence of the coastline. In the Second World War it was used by German prisoners. *Antiques Roadshow* visited the hall in 2011.

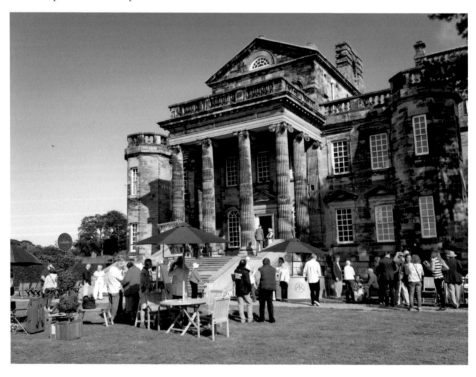

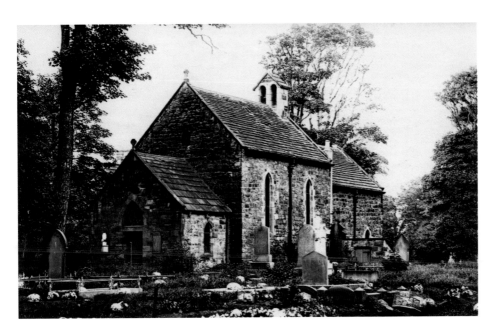

Parish Church, Seaton Delaval, *c.* 1914

The church of Our Lady was built in 1102 as a private church for Hubert de la val (Delaval), close to an earlier castle of which no remains can be seen. The family had originally come to England with William the Conqueror and were given land in the North East. The church became the parish church in 1891 and remains to this day. It is independent of Seaton Delaval Hall, which the National Trust has owned since 2009. Little has been altered since it was built in the Norman fashion, apart from the addition of a porch on the west end in 1895.

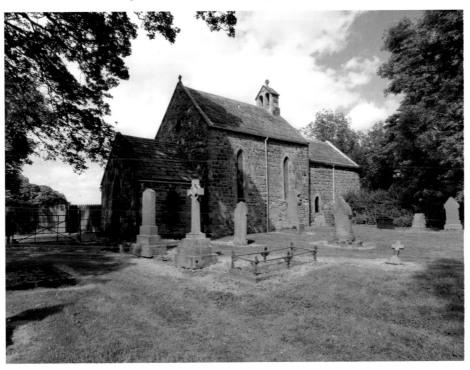

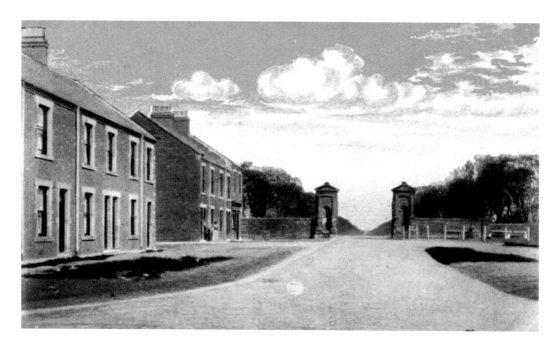

Avenue Entrance, Seaton Delaval

The estate of Seaton Delaval Hall was separated from surrounding estates by ha-has, walls, fences and Holywell Dene. The entrance to the estate from the village of Seaton Deleval was along an impressive avenue of trees around one mile in length and through a gateway with stone wings. The postcard is postmarked 1905 and shows the original gateposts in position. The road has been widened in more recent times, and stonework has been used either side of the road to enhance the approach to the Avenue.